ESSENTIAL FOR ALL TRADITIONAL & DIGITAL ARTISTS

DRAWING

BASICS

MADE EASY

FOREWORD BY
BRUCE LEWIS

FLAME TREE
PUBLISHING

CONTENTS

This chapter will show you how to draw heads and faces, how to get the proportions right and how to vary the basic shape of the head to suit different types and ages of subject. Our artists will give you guidelines to achieve a great result, whether you want a realistic portrait or a cartoon character.

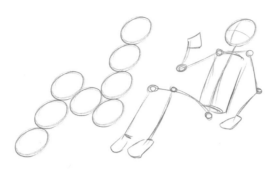
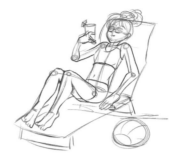

BODIES

Drawing the human anatomy can also be broken down into a series of simple steps. Observation is the key to success – look at photographs and works of art, and try breaking each figure down into the kind of shapes and lines used by our artists in this chapter. Whether you work from a model, a photo or another drawing, careful study makes for a better picture.

NATURE & LANDSCAPE

Drawing the world around us is a wonderful exercise for any artist. For beginners, it's a good idea to practise drawing the animals you're most likely to see around you every day and the kind of landscapes you can easily visit. Remember, observation is the key to good drawing, so look at your own surroundings – you may be surprised at the diversity of nature in your area.

PERSPECTIVE

There's a saying that there are no straight lines in nature, but in art we use perspective to represent this curved world through a grid of straight lines. Perspective can look perplexing but don't worry; our team of tutors will guide you through the basics.

CLOTHING

Clothing tells its own story. Whether it's historical dress, national costume, high fashion or hand-me-down rags, it lets us form an immediate impression of the wearer and his or her world. Glamour girls, fantasy figures, everyday life or images of nostalgia, what people wear – and don't wear – is fun to draw.

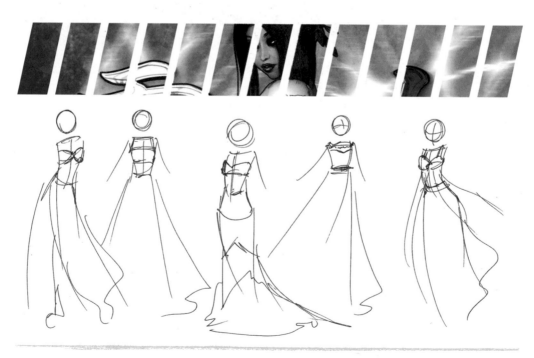

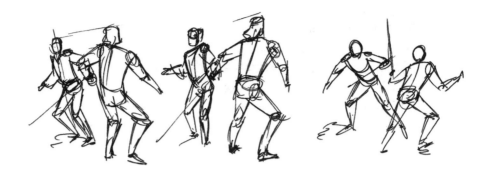

MAKING PICTURES

All your practice at drawing living things, working out perspective and observing life comes together when you combine figures with other elements to make a picture. Whether you're just observing and recording a moment in time, or creating a scene that tells its own story, your art will be unique. Make it as memorable as you can by applying your own style to everything you've learned.

FOREWORD

STARTING FROM ZERO

When I was a wee lad, and the time came to fill out my Choice of Future Vocation Card, I naturally picked Astronaut, like all kids my age did. Sadly, I didn't have the maths for it. My second choice, Dapper International Gentleman Jewel Thief (the Kind that Eschews Violence and Steals for Sport Rather than Material Gain) was open, but I was too short for the gig. Thankfully, I was suited both by temperament and talent for my third choice, Professional Artist, and that's why I'm here.

When Helen asked me to be a part of this book, I was thrilled. I have been teaching perfect strangers to draw for over 20 years at conventions all over America, plus I wrote a book of my own on the topic about a decade ago (still in print!). The thing is, however, that I had always taught with the idea that the people I was teaching were at least somewhat experienced at drawing, if only at a hobby level. This job was different: the opportunity to address learners who were starting from zero.

And that's exciting. Because zero is where it all starts. Zero is the point from which anything can happen. By being a part of teaching absolute beginners how to draw, we would have the chance to really get folks started off on the right foot. That's a start worth being part of.

And so I commend this book to those of you who are absolute beginners at the craft of drawing. In its pages you will find tips, tricks and techniques that, well followed, will enable you to leap from zero to some positive integer of progress right away. In these pages, you will gain instant access to the basic skills of practised professional artists, demonstrated step-by-step in words and pictures that make them clearly understood. Follow along and you will be drawing in no time at all.

I have said it a thousand times: drawing is a skill, not a talent. Talent is nice, sure, but not everyone is born with it. Skill, on the other hand, is not inherited: it is developed by continuous and enthusiastic self-motivated practice. Whether you have talent or not is unimportant. You can

learn to draw and draw well, but you have got to really want to do it, and you have got to be willing to sacrifice for it: sacrifice your free time, your other activities, even (to some degree) your physical comfort.

Now, don't get me wrong. I am not saying that learning to draw is a soul-crushing grind; learning is hard work, but it is satisfying hard work. All you need to do is follow the steps found in this slim volume. If you do, then I guarantee that you will sooner or later find yourself drawing better and faster than you ever believed you could.

Drawing is work. Drawing well is hard work. But when you look down that first time and realize that the example of polished draftsmanship you see before you is the product of all your hard work, well my friend, it will all be worth it.

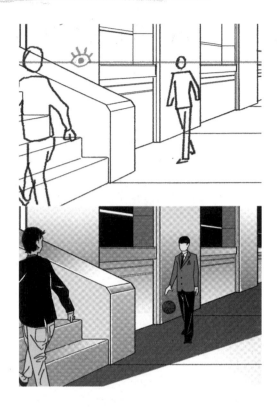

It is to you, the aspiring artist determined to master the basics of drawing (and to all those who have given up their dreams of international jewel thievery for the sake of art) that this book is respectfully dedicated.

I would like to offer special thanks to Miss Ryo Ueda for her willingness to model poses for this book; to Laura Bulbeck, Senior Project Editor at Flame Tree Publishing for her many invaluable assistances and kindnesses to me during production; to my wife Mundee and to my children for their patience and understanding; and of course to Helen McCarthy, my dear friend, colleague and veteran of the Long March.

Bruce Lewis
Illustrator, writer, graphic designer

INTRODUCTION

How often have you heard people say 'I can't draw?' You may even have said it yourself. Yet, that's not the case. Anyone can learn to draw, and have fun doing it.

WHY DRAW?

The aim of this book is to help you learn the basics of drawing, to build your confidence and to help you develop your own personal style.

But why would anyone want to learn to draw in these days of phone cameras, selfies and photo-sharing? Because a drawing is unique. Anyone can take a photograph of a flower, a cat, a building, a person – but a drawing is a one-off, a personal view of a moment in time.

Artists have so many ways of making pictures – from stick figures and collages to a carefully observed anatomical drawing; from the simplified dynamism of superhero comics to fluffy animals and wide-eyed children. But many of the greatest artists start with drawing as the foundation of a great picture.

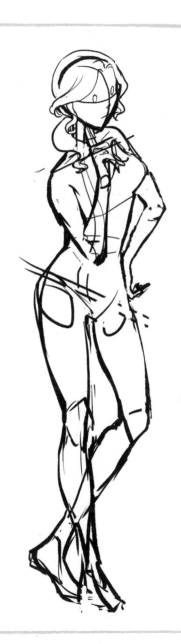

To start drawing, you only need three things: something to draw with, something to draw on, and something to draw. Just get a pencil or felt-tip pen and a piece of paper, and this book will show you how to create your own pictures.

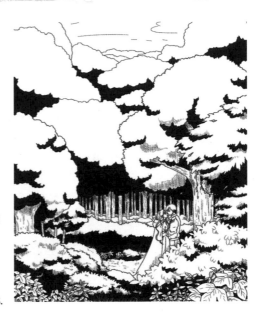

HOW THIS BOOK WORKS

Through a series of projects, each one explained by an artist in clear drawings and simple captions, you will practice the skills every artist needs. You will learn figure drawing, perspective, landscapes, and how to combine these elements.

The artists in this book have a range of different styles, and they explain the projects in their own words. As you will see, they bring very different approaches and ideas to similar subjects – but they all draw well, and by imitating their techniques you too will learn to draw well. Look out for quick tips throughout the book – professional shortcuts that will help you work smarter.

A best-selling book recently suggested that it takes about ten thousand hours of practice to become really good at anything. It's easy to be intimidated by such big numbers, but don't let that put you off. Learning to draw well need not take years. It's true that the more you draw, the better you will draw, but if you follow the principles our artists show you, you will soon achieve good results.

You will see that the principles of drawing are very straightforward and simple to learn. By looking carefully at anything, you can work out the basic shapes that make it up. Once you've grasped how those shapes lock together to make a whole object, you can learn how to put them down on paper and expand them into a picture that captures the original in your own way.

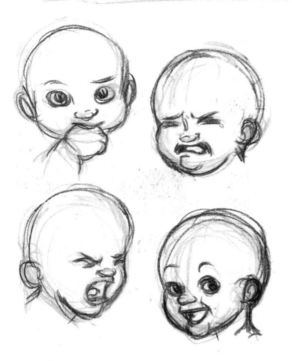

THREE HABITS OF SUCCESSFUL ARTISTS

Whether they are amateurs or professionals, successful artists have three things in common.

1. Successful artists draw almost every day – drawing is a habit with them. From quick scribbles to capture a facial expression or movement to detailed drawings from life, they keep on drawing so as to improve their skills and provide material for more detailed pictures.

2. Successful artists set aside time for serious practise. Like musicians or dancers, some artists take classes two or three times a week. If they can't fit formal classes into their schedule or budget, they practice with figure drawing or still life drawing at home, follow online tutorials, or work from books such as this.

3. Successful artists copy other artists – not to try and pretend that the work is their own, but to practice the techniques used by artists they admire, and to adapt them to their own style.

All three habits improve hand-to-eye co-ordination and muscle memory. Muscle memory – the way your body learns to carry out movements correctly by repeating them over and over again – is just as important to artists as to dancers or athletes. To draw a picture you have to make your hand move exactly as you want it to, and that takes practice.

GETTING THE DRAWING HABIT

🖼 Buy a small hardback notebook that you can easily carry around and pull out anywhere. It does not have to be expensive – lined paper is fine. Felt-tips or even biros can be more convenient than pencils on the move, because they don't need sharpening.

🖼 Fill at least one page of the book every day with sketches of anything that catches your interest – cars, trees, shoes, anything. Make them very quick and simple, and always sketch from life.

🖼 Work through at least one of the projects in this book every week. Copy it carefully in every detail so that you understand the skills and techniques.

🖼 If you have time for a second weekly session, use the techniques in this book to draw a friend, a pet, or that old art school classic, a pot plant or bowl of fruit.

🖼 Look at as many pictures as you can and copy the ones you like best. Compare your finished work with the original and see where it differs.

🖼 To begin with, keep your equipment simple. You can buy more materials when you find what suits your own unique style. That particular style will only develop as you learn, so just pick up a pencil and a piece of blank paper and try one of these projects.

🖼 Have fun!

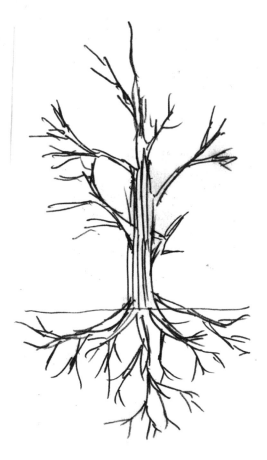

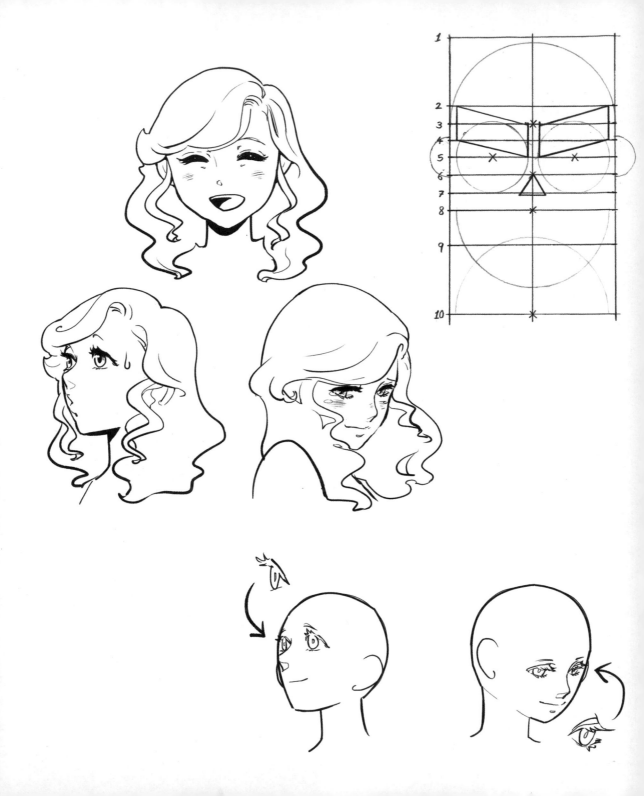

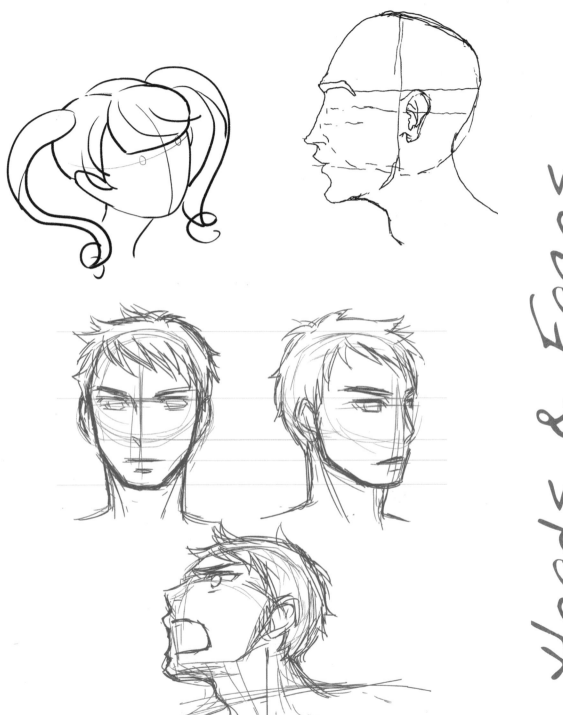

Heads & Faces

HEADS

Drawing the human head is easier than you think: break it down into simple shapes and take time to get the proportions right.

MALE HEAD 1
BY NEWTON EWELL

Step 1

Most of us would start out drawing a male head by looking at a person or photo and sketching what we see. I've put in a few guidelines for the placing of the features. But it looks a bit hesitant, right? There's an easier way to do this with confidence.

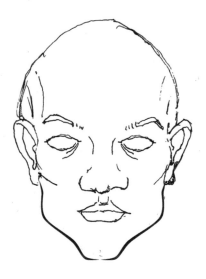

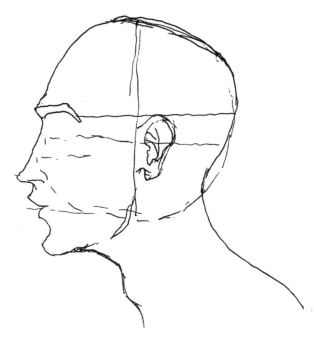

Quick Tip: Throughout this book, the pictures will convey more information about how to draw than the text – take the time to look carefully at every stage!

Step 2

The **circle** is the top part of the skull, the **oval** the cheekbones and jaw. The **triangle** you see right in the middle defines the relationship of the mouth and eyes. The black lines define the centres of the eyes and nose.

Step 3

Using this grid you can place the features and adjust their size. In most faces, the proportions of each feature stay the same relative to each other.

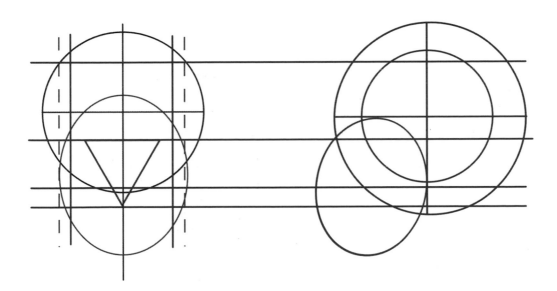

Quick Tip: If you have a drawing program on your computer you can print out shapes and gridlines to use as a basis for hand-drawing practice. It will save you some time!

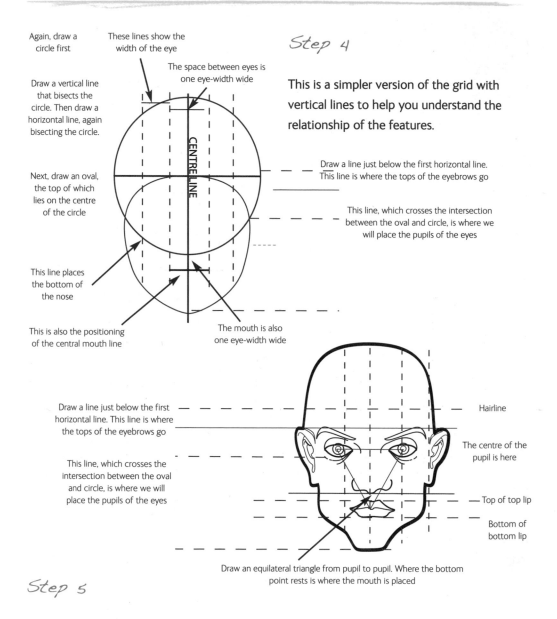

Again, draw a circle first

These lines show the width of the eye

The space between eyes is one eye-width wide

Draw a vertical line that bisects the circle. Then draw a horizontal line, again bisecting the circle.

Next, draw an oval, the top of which lies on the centre of the circle

This line places the bottom of the nose

This is also the positioning of the central mouth line

The mouth is also one eye-width wide

CENTRE LINE

Step 4

This is a simpler version of the grid with vertical lines to help you understand the relationship of the features.

Draw a line just below the first horizontal line. This line is where the tops of the eyebrows go

This line, which crosses the intersection between the oval and circle, is where we will place the pupils of the eyes

Draw a line just below the first horizontal line. This line is where the tops of the eyebrows go

This line, which crosses the intersection between the oval and circle, is where we will place the pupils of the eyes

Hairline

The centre of the pupil is here

Top of top lip

Bottom of bottom lip

Draw an equilateral triangle from pupil to pupil. Where the bottom point rests is where the mouth is placed

Step 5

Here you can see the way the features fit onto the geometric shapes. Once you have the positions right, you can start to adjust the individual features.

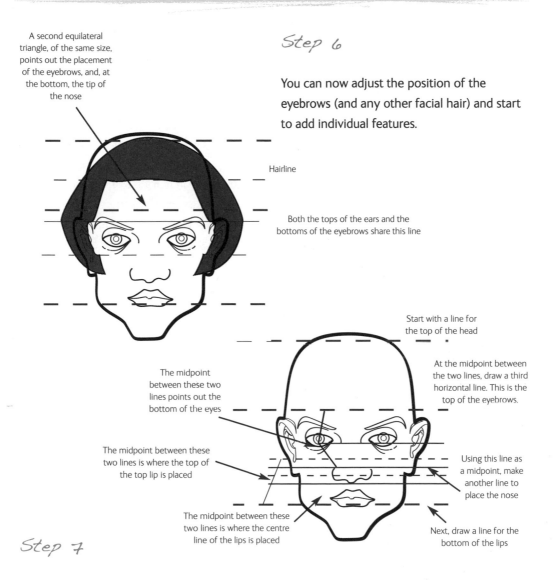

A second equilateral triangle, of the same size, points out the placement of the eyebrows, and, at the bottom, the tip of the nose

Step 6

You can now adjust the position of the eyebrows (and any other facial hair) and start to add individual features.

Hairline

Both the tops of the ears and the bottoms of the eyebrows share this line

Start with a line for the top of the head

At the midpoint between the two lines, draw a third horizontal line. This is the top of the eyebrows.

The midpoint between these two lines points out the bottom of the eyes

The midpoint between these two lines is where the top of the top lip is placed

Using this line as a midpoint, make another line to place the nose

The midpoint between these two lines is where the centre line of the lips is placed

Next, draw a line for the bottom of the lips

Step 7

Some artists like to start with the hairline, but while you're learning you'll find it easier to draw the basic skull first and then adjust the hairline once you're happy with the facial features.

Artist Info: Images © Newton Ewell. Website: www.newtonewell.com

MALE HEAD 2
BY CHIE KUTSUWADA

Step 1

Here, we'll draw three different angles of the same male character. First, make the rough planning drawings. At this stage, it is not really an issue if the character is or isn't male. Just think about getting the angles right.

Step 2

Make the more detailed rough drawings. The squarer jaw, chin and wider neck are often very effective in making a character look masculine. Also, pay attention to how the same person looks in different angles. Using some guidelines might help to balance the positions of the facial parts.

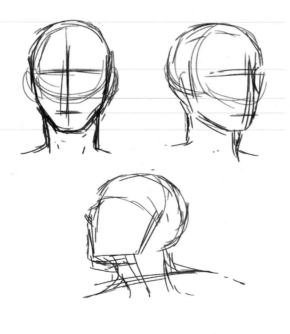

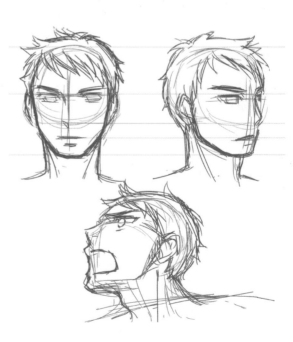

Step 3

Start inking from the face line. Using fairly straight lines – rather than curvy ones – makes the character look masculine. By the way, it doesn't matter if the subject is male or female, but please do not forget to give enough roundness and volume to the back of the head, in order to create a well balanced head.

Step 4

Inking continues to the neck. Again, use quite straight lines. Also, adding an indication of an Adam's apple has a great effect on the masculinity of the character. Here I ended up drawing someone who is not too skinny but not extremely well built.

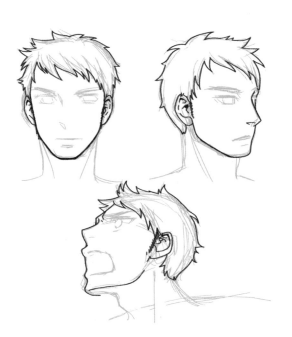

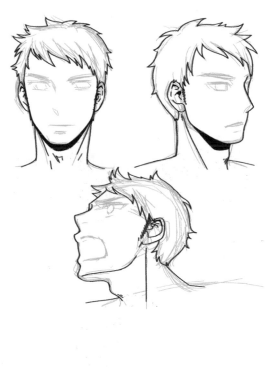

Quick Tip: Some of the artists in this book use a **pale blue pencil** for initial sketches. Blue doesn't show up as strongly as black in copying or printing, so there's less need to erase stray lines if your work is to be printed.

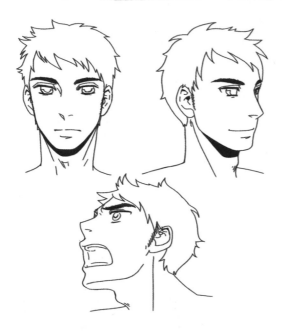

Step 5

Knowing how your personal average male and female characters look is quite important – you can adjust portrait drawings to make sure you're not always drawing the same type, even in your own style.

Add the facial features with some expressions. Again, the eyes are drawn with quite straight lines. Strong eyebrows, chunkier nose and lips are great features for a straightforward passionate hero-type. Dynamic facial expressions, such as the drawing on the bottom, are also good in enhancing masculinity.

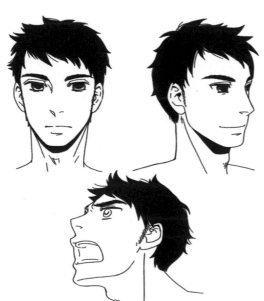

Step 6

Paint the hair and the pupils black, and also do some shading in the eyes. I added some random strands of hair to make his hair look natural.

Step 7

Complete the drawing with highlights and effects. Too many highlights, especially in the eyes, don't work on a male character – but without highlighting in the eyes, the face looks too gloomy or blank, and can even look menacing. So add highlights in the eyes very carefully!

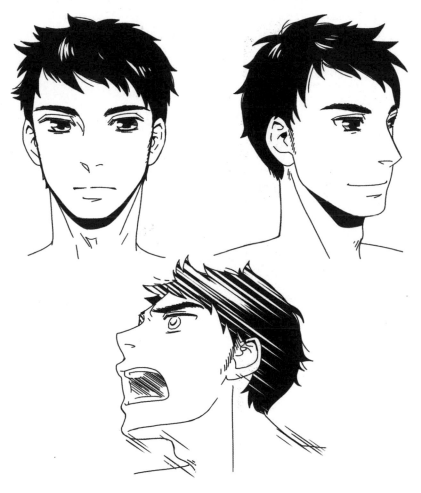

Artist Info: Images © Chie Kutsuwada. Website: www.chitan-garden.blogspot.com

FEMALE HEAD 1
BY NEWTON EWELL

Step 1

Just drawing what you see is quite typical as a starting point. I've sketched in some guidelines and shapes, but it's hesitant.

Greater use of the basic geometry of the head will help us make this drawing more assured and dynamic.

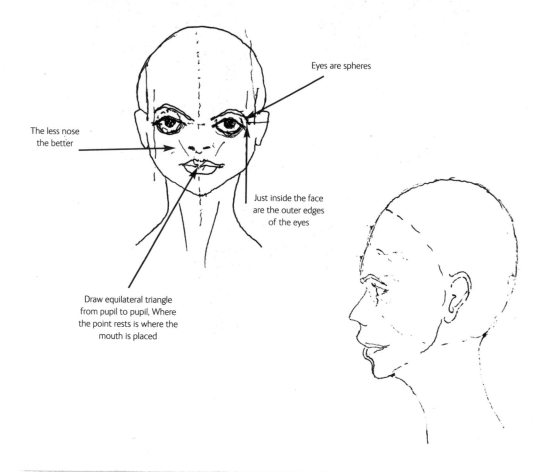

Eyes are spheres

The less nose the better

Just inside the face are the outer edges of the eyes

Draw equilateral triangle from pupil to pupil, Where the point rests is where the mouth is placed

Step 2

Here we see how using geometric shapes can help to tighten up the drawing of the profile, and to shape the eyes and ears correctly.

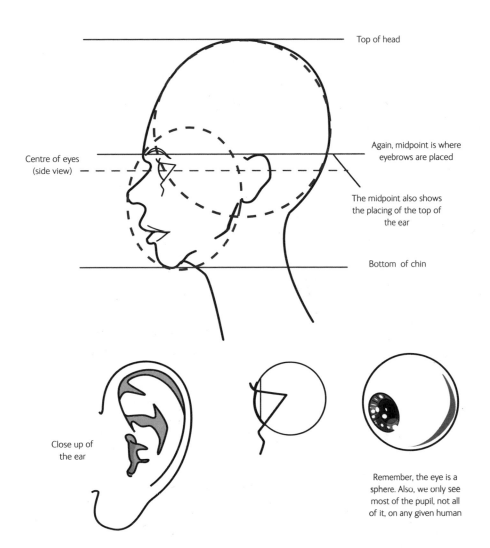

Top of head

Centre of eyes (side view)

Again, midpoint is where eyebrows are placed

The midpoint also shows the placing of the top of the ear

Bottom of chin

Close up of the ear

Remember, the eye is a sphere. Also, we only see most of the pupil, not all of it, on any given human

Step 3

On the full face, the very same techniques I used to draw a male head (*see pages 16–19*) work to help define the female head.

Step 4

Remember, this is just a base to get you started. Once you have the position of the features and the proportions right, you can work on that base to make the face you want to draw.

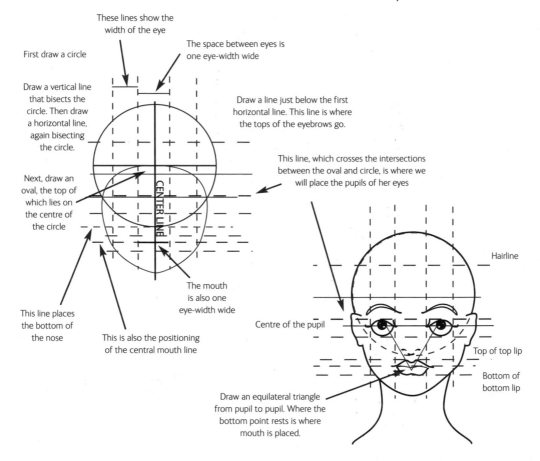

These lines show the width of the eye

The space between eyes is one eye-width wide

First draw a circle

Draw a vertical line that bisects the circle. Then draw a horizontal line, again bisecting the circle.

Draw a line just below the first horizontal line. This line is where the tops of the eyebrows go.

CENTER LINE

Next, draw an oval, the top of which lies on the centre of the circle

This line, which crosses the intersections between the oval and circle, is where we will place the pupils of her eyes

Hairline

This line places the bottom of the nose

The mouth is also one eye-width wide

Centre of the pupil

This is also the positioning of the central mouth line

Top of top lip

Bottom of bottom lip

Draw an equilateral triangle from pupil to pupil. Where the bottom point rests is where mouth is placed.

Quick Tip: Use a lightbox to help you make a tracing of your base drawing so that you can work on it without needing to erase or hide lines. If you don't have a lightbox, tape your drawing to a windowpane so the daylight comes through it.

Step 5

Women often have – or create – a higher eyebrow line than men. Sometimes it vanishes under the hairstyle, but you need to know where it is!

Step 6

Getting the **proportions** of the face right will help you achieve a natural drawing, so rule **lines** and **triangles** as often as you like. Remember, you can trace the result onto a clean sheet of paper once you're happy with it.

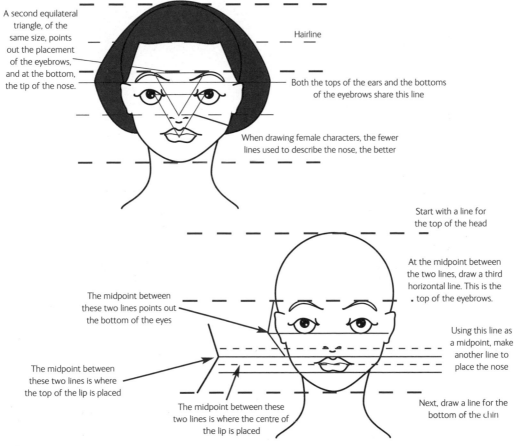

A second equilateral triangle, of the same size, points out the placement of the eyebrows, and at the bottom, the tip of the nose.

Hairline

Both the tops of the ears and the bottoms of the eyebrows share this line

When drawing female characters, the fewer lines used to describe the nose, the better

Start with a line for the top of the head

At the midpoint between the two lines, draw a third horizontal line. This is the top of the eyebrows.

The midpoint between these two lines points out the bottom of the eyes

Using this line as a midpoint, make another line to place the nose

The midpoint between these two lines is where the top of the lip is placed

The midpoint between these two lines is where the centre of the lip is placed

Next, draw a line for the bottom of the chin

Artist Info: Images © Newton Ewell. Website: www.newtonewell.com

FEMALE HEAD 2
BY INKO

Step 1

I would like to show a female head drawing in three different angles so that you can have a **three-dimensional** understanding. For a feminine portrait, make lines curvy, with a smaller jaw and thinner neck than the little male head sketched next to the top image.

Step 2

Adding eyes and ears: here you can see how the combination of the eyes and ears creates the angle of the face: when she looks straight, the features are aligned. She looks up and her ears are lower than eyes; she looks down and her ears are higher. Very simple!

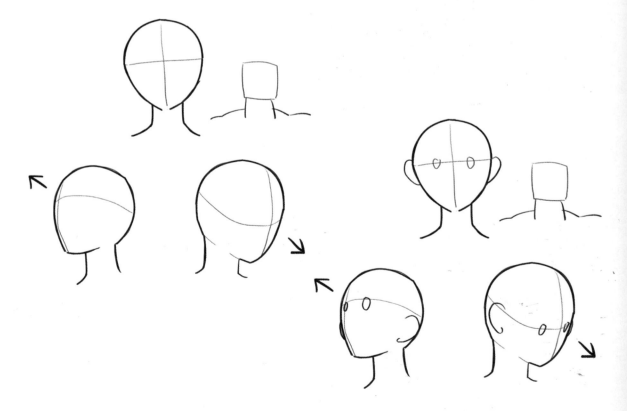

Step 3

Now the picture starts evolving from a basic chunk of clay into a human. The nose line is clearer when the face is at an angle and the distance from the mouth to the nose further when looking up, closer when looking down. Also compare the feminine smile with the masculine one next to it.

Step 4

Drawing female eyes is fun. Eyelashes give perspective and a wide range of expressions. Most people think bigger, rounder pupils look friendly, and smaller thinner ones look evil!

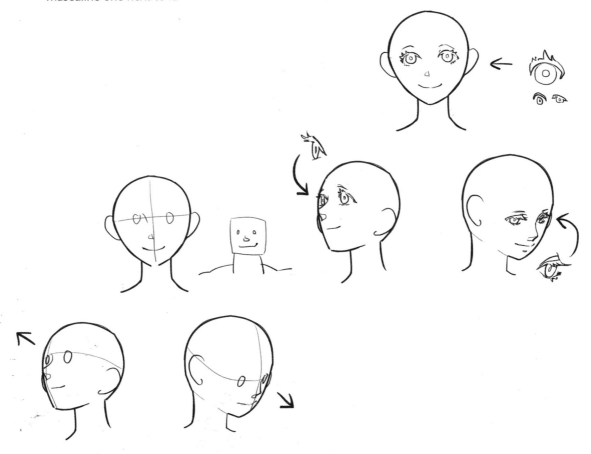

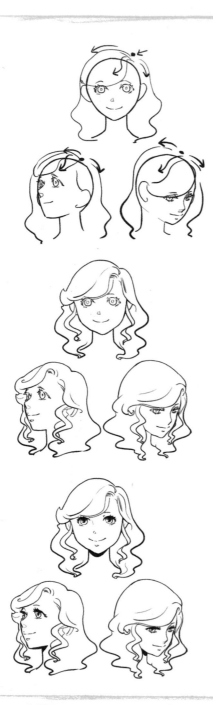

Step 5

Any style of hair has its flow. No matter whether the hair is short, longer, spiky or curly, there is a point where the flow starts – this is the crown. The black spots on the figures are the starting points. Keep in mind that all hairlines originate from there.

Step 6

Here is a long, wavy hairstyle, drawn from three angles. Whichever way the person is looking, you can see she is the same person from the hairstyle. Look how hair separates itself naturally, and consider texture too.

Step 7

Don't over-shade the face. You do not have to demonstrate all the shadows on the human head. Choose only what you wish to emphasize.

Step 8

Of course, when you apply these techniques in a life drawing, your subjects may not stay still. They have personality and expressions: they laugh, they're puzzled, they may even feel shy. Practice hard to capture all these expressions!

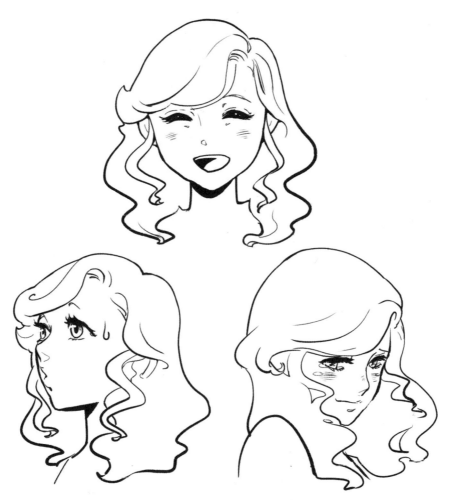

DEVELOPING SKILLS

In this section we'll explore how to draw the head from different angles, as well as the art of cartooning.

CARTOON HEADS 1 – PROPORTION, ABSTRACTION, STYLIZATION
BY BRUCE LEWIS

Step 1

So let's draw a cartoon head. We start with ye old football shape, with **centreline** and **eyeline** drawn in. Let's make this basic shape into four different cartoons.

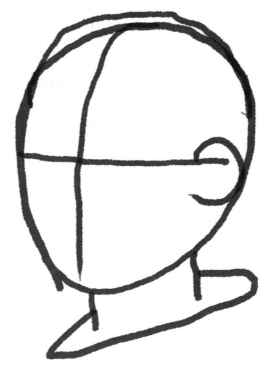

Quick Tip: Drawing cartoon heads is the same process as drawing a realistic human head. The difference lies in proportion, abstraction and stylization.

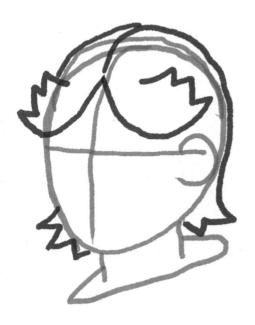 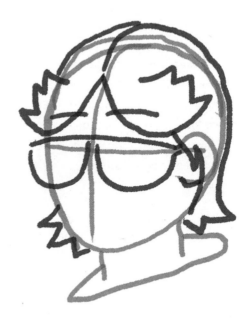

Step 2

Since this cartoon is meant to suggest Yours Truly as a junior high school student *c.* 1978, we'll start with the most important feature: hair. I, like millions of other teenagers, sported the *de rigueur* 1970s centre-parted, wing-sided hairspray comb-back 'do. Hair is stylized here as the spray-stiffened helmet that it was, not as individual strands.

Step 3

Then, as now, I wore glasses, so here they are. In those days only a hopeless nerd would wear the big, black, plastic Fidel-Catro-1959 specs I sport today; instead, it was gold-anodized wire-rimmed coke-broker aviator glasses with Polaroid lenses all the way. Notice how I've reduced them to just a few lines. That's cartooning, folks!

Quick Tip: The cartoon head is usually considerably larger (or otherwise out of proportion) compared to the body. Its features are stylized as symbols rather than drawn as depictions.

Step 4

Facial features, clothing and so forth go on at this stage. Again, notice how I'm keeping everything as simple as possible. That's because the essence of cartooning is suggestion rather than blatant depiction. The fewer the lines, the better.

Step 5

And here I am: the Me of 1977, Sears plaid flannel shirt and all. The 1970s were not the decade of cool you have been led to believe. They were instead a sweaty, tacky and frankly ugly period that (in my opinion) are best forgotten by all concerned.

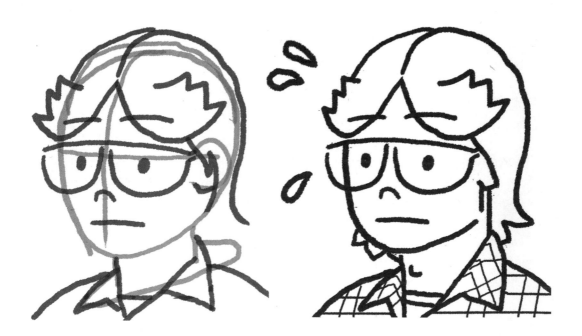

Quick Tip: Different materials will give your cartoons a different feel. Try using charcoal, magic markers or crayons, or their digital equivalents. Keep the colours bold and simple.

Step 6

This is a cartoon of me drawn in a sort of late 1970s, quasi-**manga** style. Notice the angular, dangerous-looking pointed hair; the knitted kabuki brows, the gigantic sidewall collars. Speed lines in the background add drama and eliminate the need to draw time-consuming background art.

Step 7

And here I am, drawn in the style of Hergé. The so-called **Clear-Line Style**, made famous in *Tintin* and in about a million other French and Belgian comics over the past 85 years or so, is deceptively difficult to mimic; you go in thinking it's all just dots and swashes, then find out it's more akin to writing Chinese calligraphy.

Artist Info: Images © Bruce Lewis. Website: www.brucelewis.com

CARTOON HEADS 2 - A SIMPLE SYSTEM FOR CARTOONING BY DAN BYRON

Step 1

Using a ruler and pencil, draw a rectangle 20 cm (7.9 in) tall and 12 cm (4.7 in) wide. Mark points 5 cm (2 in), 10 cm (3 in) and 15 cm (6 in) along each of its sides and 6 cm (2.4 in) along its top and bottom. These marks will help you draw the guidelines needed to put all the facial features in the right place.

Step 2

Draw one vertical line and three horizontal lines that will split the rectangle into eight even pieces. Next mark points at 6.3 cm (2.5 in), 7.5 cm (3 in), 8.7 cm (3.4 in), 11.3 cm (4.4 in) and 12.5 cm (4.9 in) down each side of the rectangle. Use these to draw more horizontal lines. I'll refer to each of these lines by number from now on.

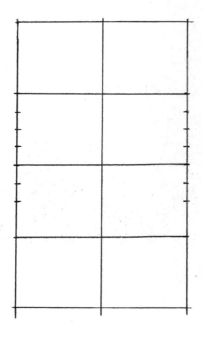

Step 3

First mark a point in the centre of line 3. Then add two points at 3 cm (1.2 in) and 9 cm (3.5 in) along line 5; these will be the central points of the character's eyes. Next mark a point halfway along line 6 and another halfway along line 8. Mark one more point halfway along line 10. For ears set the compass to 1.5 cm (0.6 in) and use line 5 as the point to draw semi-circles on each side of the rectangle.

Step 4

Set your compass to 6 cm (2.4 in). Using the mark halfway along line 3, draw a semi-circle upwards that will almost touch line 1. Next set the compass to 2.5 cm (1 in) and using the two marks on line 5 as the central points, draw two full circles. Now set the compass to 5.5 cm (2.2 in) and draw a downwards semi-circle that will be the curve of the mouth. Using the mark in the middle of line 10 draw a semi-circle upwards, this will be the curve of the character's tongue inside his mouth.

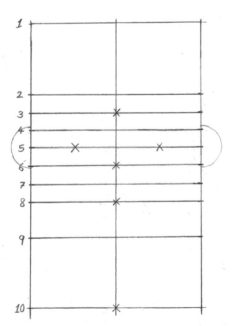

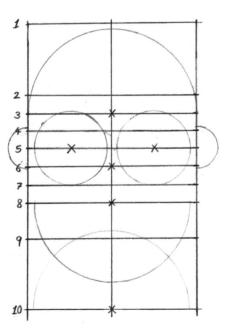

Quick Tip: Try using this method with lots of different combinations of shapes to make all sorts of crazy faces.

Step 5

Next we'll add eyebrows and a nose. First mark points at 0.5 cm (0.2 in), 5.5 cm (2.2 in), 6.5 cm (2.6 in) and 11.5 cm (4.5 in) along line 3. Use the marks at 0.5 cm (0.2 in) and 11.5 cm (4.5 in) to draw small vertical lines that touch lines 2 and 4. Then draw similar vertical lines on the 5.5 cm (2.2 in) and 6.5 cm (2.6 in), this time though the vertical lines will touch lines 3 and 5. Join these two sets of marks with slanted lines to create the character's chunky eyebrows. Now, draw a small triangle using the mark in the middle of line 6 as its top point. It should have a 2 cm (0.8 in) wide base just below line 7.

Step 6

Finally, mark a point 2 cm (0.8 in) above the centre of line 1. Then, using a compass set at 6 cm (2.4 in) make a downward semi-circle that overlaps the top of the head. This is the character's hairline. Now all the features are in place, use a marker to trace the face. Try to do this part carefully and neatly. For this character, I curve the edges of the nose and the jawline at the bottom of the rectangle. For the top of the mouth, just follow line 8 between the two sides of the semi-circle.

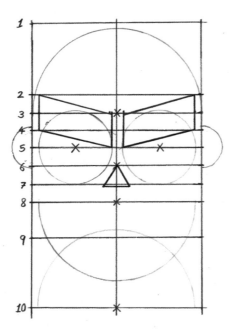

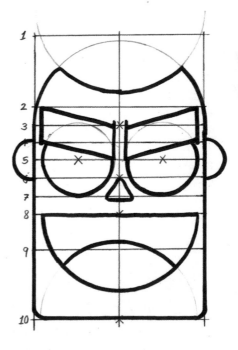

Step 7

When drawing the pupils of the eyes, place them somewhere just inside the central mark that was used to draw the outline. Slightly crossed eyes give a better impression that the character's looking straight forward. Now use an eraser to rub out all the pencil guidelines. I prefer to add hairstyles in freehand afterwards.

Step 8

I usually give this character spiky black hair and sideburns but you can give him any sort of haircut you like. You should also add a small line inside each ear and maybe even little details like zigzags under the eyes or creases at the sides of the mouth.

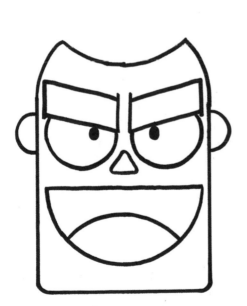

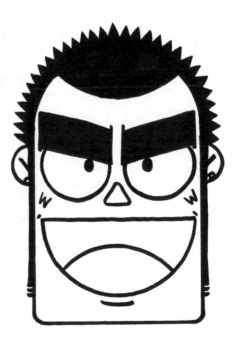

Artist Info: Images © Dan Byron. Website: www.facebook.com/badeggcomic

PROFILES BY INKO

Profiles are drawn in exactly the same way as full-face heads, by breaking down what you see into simple shapes and observing the distances between shapes and the relative sizes.

Step 1

Every human head has a unique shape. It is always best to sketch a real one in order to understand it. The little sketch at bottom left shows how to **curve** out a human skull from a circle. Yes, the human skull is not completely round!

Step 2

When you draw a neck in a **profile**, where would you position it? That's right, *not* in the middle. A slightly rear position is the correct way to go! The neck links to the spine so it can support the weight of the head at the back.

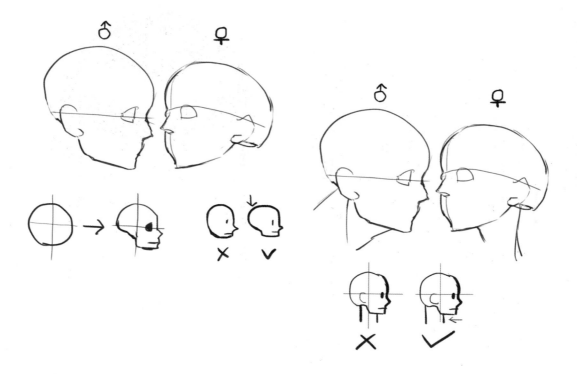

Step 3

The relationship between the eye and the ear decides where the subject is facing. When he or she looks up, the ear is lower; when they look down the ear is higher. Hence, the female figure on the right is facing slightly upwards.

Step 4

Eyebrows are very expressive. Use them to show your subject's feelings. Rising eyebrows show surprise or excitement, saggy ones show sorrow or fear. Quite often male eyebrows are drawn closer to eyes, almost touching, and female ones are further above the eyes.

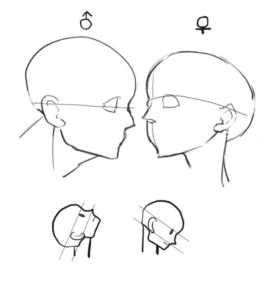

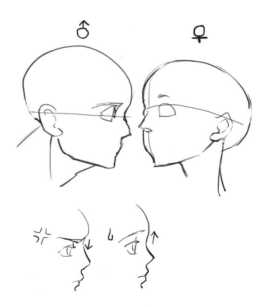

Quick Tip: Remember to make a male subject's jaw squarer and neck thicker than a female's. Don't forget the Adam's apple!

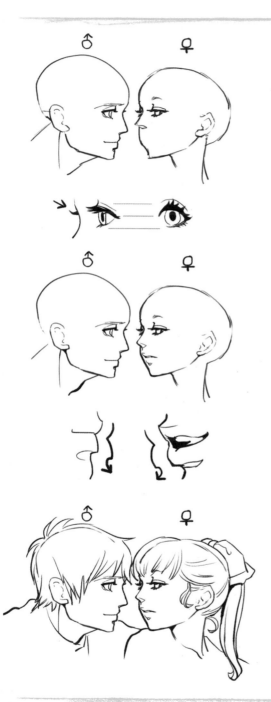

Step 5

Eyes in profile need extra care with **perspective**. In the sketch at the bottom, the eye has a triangular shape. The pupil elongates and narrows until it looks vertical. Don't forget to show the tips of the eyelashes on the other eye.

Step 6

How hard can it be to draw a mouth from the side? You can immediately spot the difference the shape makes – more emphasis on lips makes the right-hand subject look feminine. You can control the look: masculine/feminine, noble/sensual, happy/angry by different emphasis on the lips.

Step 7

As you see, the hair is not drawn directly on top of the skull lines – it springs above the skull to express the volume. Though the left figure has spiky hair, the flow is not random. All hair flows originate from one point on the head.

Step 8

Draw the outfits and the male figure's hands resting gently on the female figure's shoulder, add **shadows** and **highlights**, and it is done! Your drawing exercise has been transformed into a beautiful piece of art!

Artist Info: Images © Inko. Website: www.inko-redible.blogspot.com

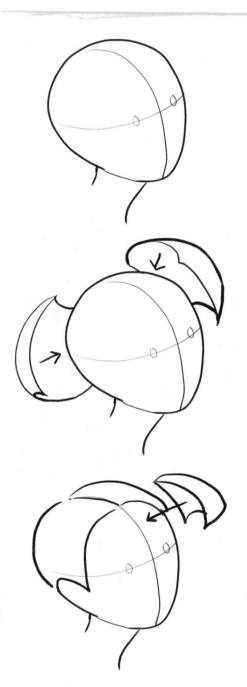

HAIR BY INKO

Step 1

To practice drawing hair you need an **egg shape** head to start. Here we have an angled view to make it easy to understand three-dimensional hair logic! Avoid making hairstyles completely symmetrical, because they will look too still and flat.

Step 2

Hair is not a pattern tattooed on a bald head, it has **volume**. I divide the hair into three groups (right side to back, left side to back, and fringe) and then I start fitting the first two onto the head.

Step 3

The fringe at the front of the head is added. No worries about it looking like a clay chunk at this stage, as we will start to carve in the details later. Now you understand the fringe is something with its own volume that covers the top of the forehead, not a pattern painted onto it.

Step 4

If your subject or character ties his or her hair into ponytails or bunches, we can add the bunch as another 'hair group'. Use curves to depict the softness of the hair texture. Be careful to place them on the head with **balance** and **perspective** in mind.

Step 5

The basic shape of hair is done! All the 'hair groups' are placed in a good position so you can already feel the perspectives of the head and the volume and texture. However, the overall look is still a bit too static.

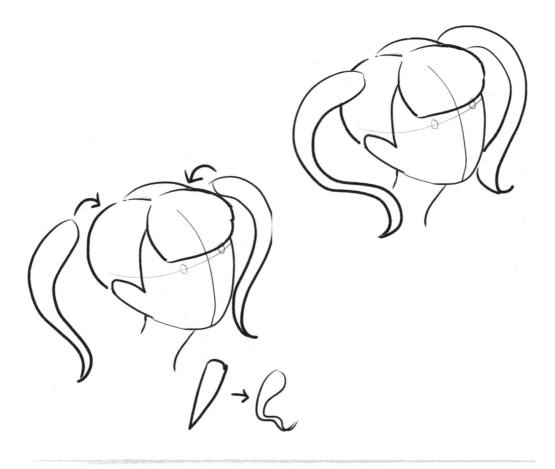

Step 6

What we need is a **flow**! Imagine a tender breeze circulating around the subject, lifting up some parts of the hair, which creates a beautiful flow. Can you see the character looks much more alive now?

Step 7

Divide the hair into even smaller groups with thick and thin lines. Think of the ponytails as strips rather than ropes, and give the lines and groups **uneven thickness** to make them more expressive. Give an extra curl at the ends of hair to show it is dancing in the air.

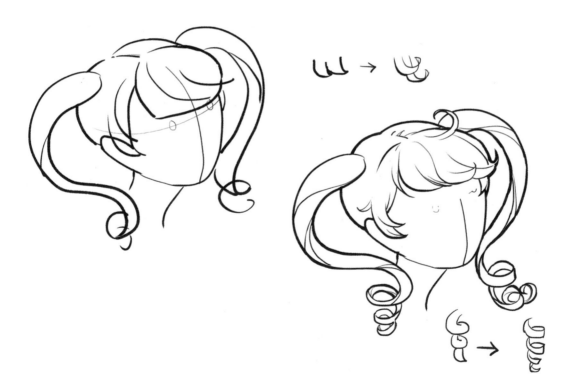

Quick Tip: Whether you're working with pencil and paper or a computer, experiment with erasing parts of lines to see how that can bring your drawing to life.

Step 8

And finished! Complete by adding some lines with extra care, making outlines thicker. Yes, you can erase or partly erase some lines too! Have a look at the section where hair softly touches her cheek and shoulders – the lines are interrupted there.

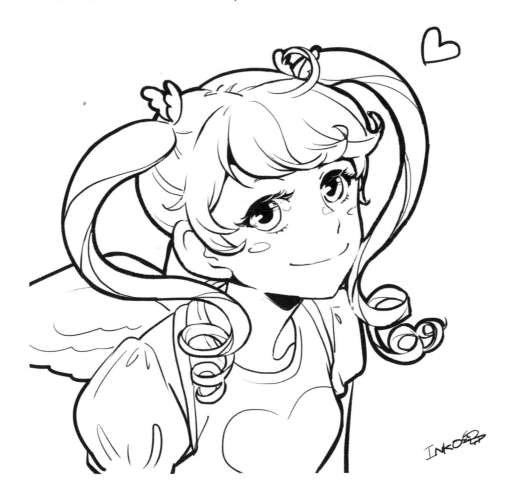

Artist Info: Images © Inko. Website: www.inko-redible.blogspot.com

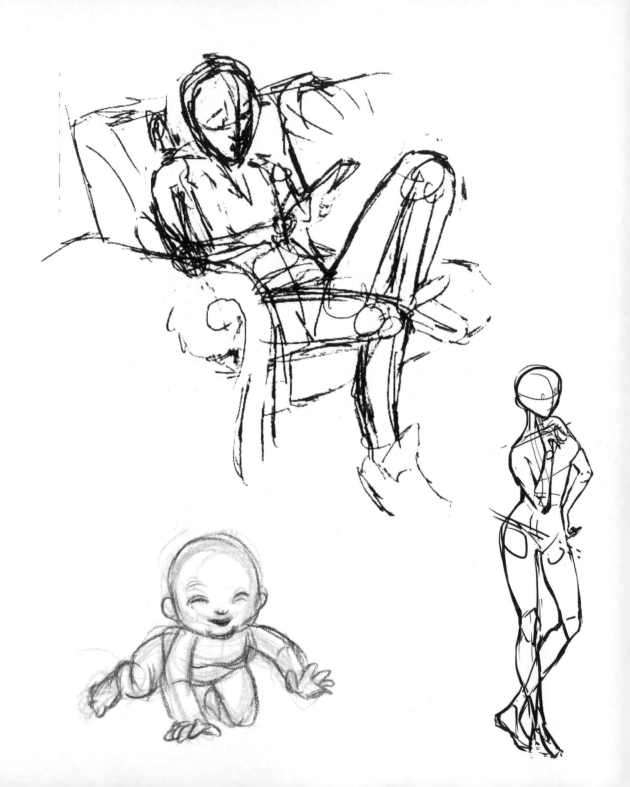

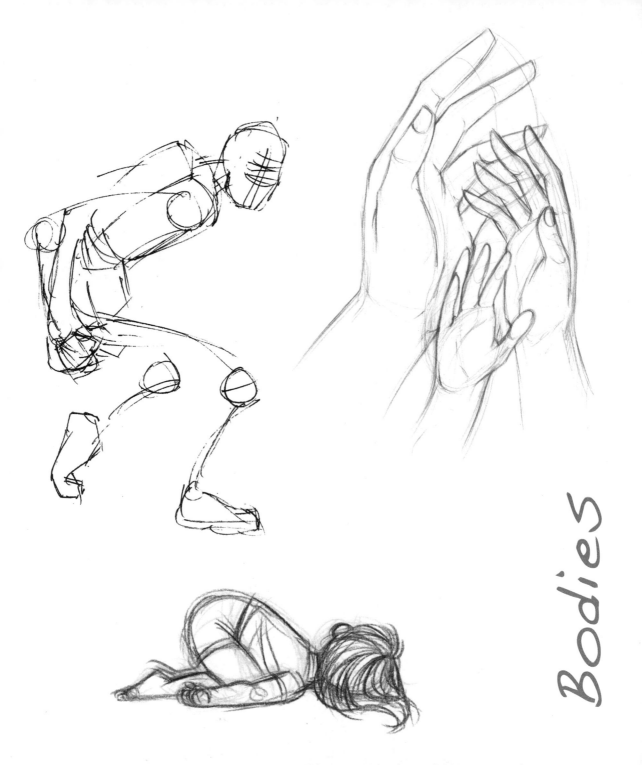

Bodies

DIFFERENT BODY TYPES

As bodies grow and age, they change, but the basic rules of drawing stay the same. Break it down into simple shapes. And, remember, you don't have to draw from the nude – careful observation can help you make accurate figure drawings in or out of clothes.

BODY PROPORTIONS AND WEIGHT
BY LAURA WATTON-DAVIES

Step 1

The circles next to these figures show the dimensions of the head of the subject. An average main character in a comic book is about **eight-heads tall** proportionally. An adult character who is not as tall could be six- to seven-heads tall. For a drawing from life, observe how many head lengths make up the body.

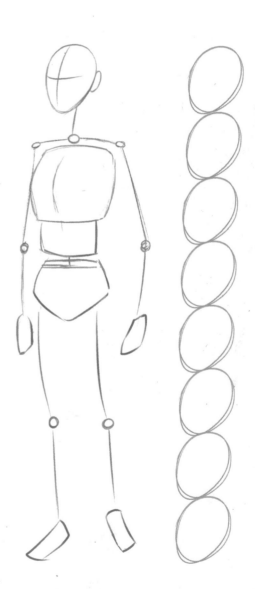

Step 1 (contd)

The rough pencil stage helps with the **volume** and **proportion** of your subject's stance. Think if they will be standing, bending, posing. Draw as many steps as you think you need and select the most appropriate one, as this is your foundation.

Step 2

Over the stick figure skeleton, drawing a rough body shape will help assist to bring your subjects and their personality to life. This is the stage where adding weight and creases to the skin structure is a good idea, as you can go over these elements in better detail later.

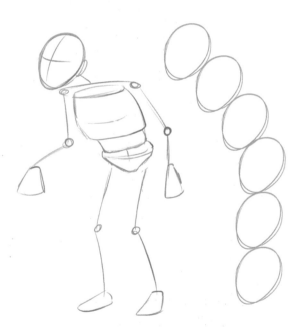

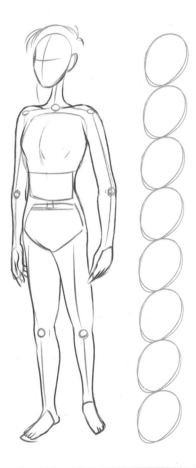

Quick Tip: If the subject is more muscular, leaner or bigger, the basic figure drawing would remain the same, but the skin and muscle would look different depending on these aspects.

Step 3

Removing the stick figure base will help give you a good sense of what needs editing or cleaning up. If you are unhappy at this stage, feel free to start again – there is no harm doing this and you can learn from your past sketches to see what will work better.

Step 4

The **inking stage** is the cleanest and most fluid stage. Simple clothing has been added. As you can see, the muscular person has wider shoulders and stronger muscle tone than a slender person. An elderly figure may not be very tall and will have more skin fold detail due to their age.

Step 5

A **rough pencil stage** shows a slight difference to male and female subjects compared to the first set of drawings. This is mainly applicable to the body area and can be drawn however best suits your figure and their personality.

Step 6

Drawing over the stick figure skeletons again is a good stage to consider body muscle and tone. You can also experiment with the weight of your character at your chosen height – note that a heavier figure will have a more rounded face, stomach, forearms and thighs.

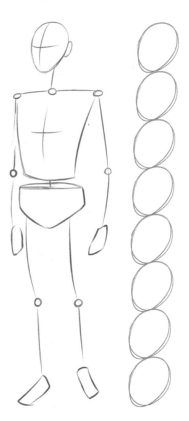

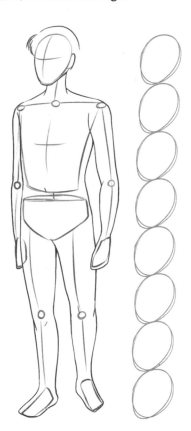

Quick Tip: Watch how different body types work in active and passive poses, and how they interact socially with others. Have fun making your drawings come to life!

Step 8

Step 7

At this stage you can tidy up the body type – perhaps emphasize or refine certain elements such as shoulders or muscle **silhouettes** to give your subject a bolder outline and sense of presence.

The pencil lines have now been inked and the final stage shows the subject's stance and body type. Clothes can be added using similar stages, and thinking about how different fabrics would sit and hang from each body type should be considered and experimented with. Experiment with different poses.

ADULT MALE BY NEWTON EWELL

Step 1

Draw a rough stick figure. This stage is important, because in the stick drawing stage you can play with **poses** and **proportions**, without fear of 'ruining' anything. I finally developed the idea of a guy who has been startled by something very strange.

Step 2

Having evolved the pose on my stick man, I'm ready to start sketching for real. Here I begin to work out the **fold patterns** on his shirt, as well as laying down basic **shadows**.

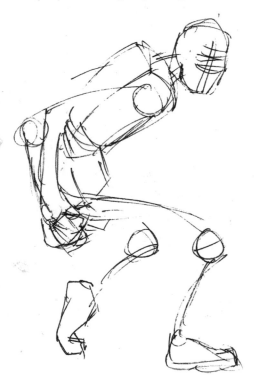
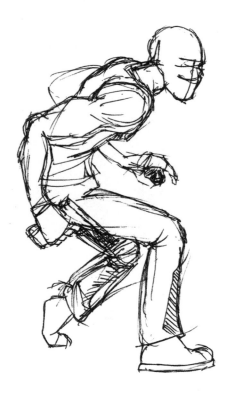

Quick Tip: Folds always form a spiral originating at the point of the bend (take a look at his right knee). This rule is true, regardless of where the 'drape point' originates.

Step 3

Once I'm ready to stop tweaking, I drop the opacity of the sketch. I'm working on a computer, by the way, but you can follow these steps with pencil and paper. It's time to get down to business. I'm not quite happy with the pose; it looks a bit unbalanced.

Step 4

I break the limbs down into **cylinders**. In this way, I get a better look at my elements and where they should be, as opposed to how I sketched them originally. I see my problem – his left leg is not properly bearing his weight. The weight of his torso is almost equally supported by both his legs.

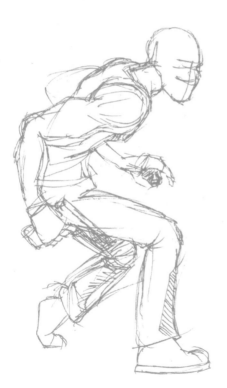

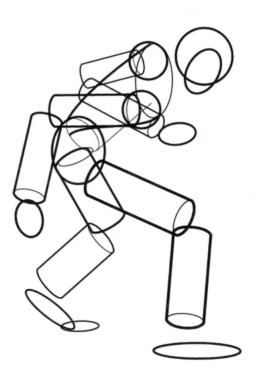

Quick Tip: Remember you can use tracing paper to copy the best parts of your rough sketches and use a lightbox or a windowpane to get the drawing onto clean paper for finishing.

Step 5

Once I have the cylinders where I want them, I drop the **opacity** of my computer sketch layer, and use my mannequin as the basis for my second, more detailed sketch. I also experiment with where the **shadows** and **highlights** will fall.

Step 6

Finally, I'm ready for inking. In the detailed sketch stage, I got rid of the gun – we see that every day on TV. Instead, I went for the Shaolin monk thing; instead of wielding a gun, he's catching an arrow.

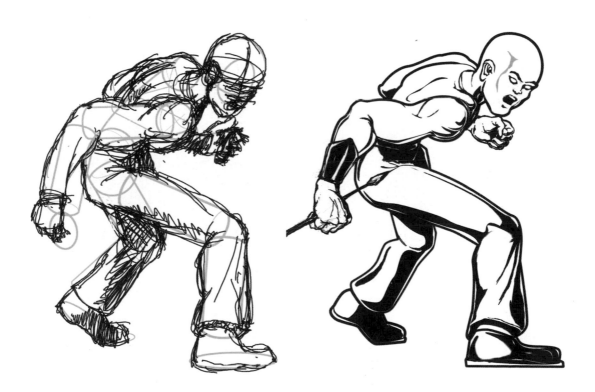

Artist Info: Images © Newton Ewell. Website: www.newtonewell.com

ADULT FEMALE BY INKO

Step 1

In this section I'll give you tips for drawing a female body by showing you the contrast with a male body. First of all, we create an upper torso, which already shows gender difference: the shape, the position of the tummy button, and chest/breast differences.

Step 2

When someone poses in a relaxed way, one shoulder often goes up while the other down – the opposite to the buttock cheeks. To put flesh on the torso, I find it is easier to apply **diamond** shapes when I draw a feminine body and **rectangular** shapes on a masculine one.

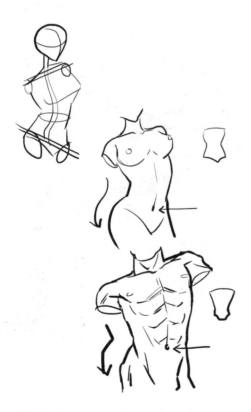

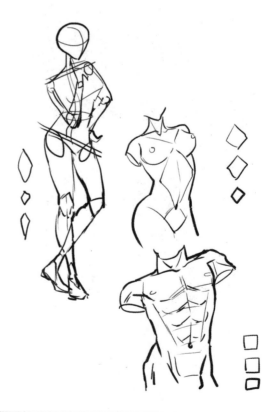

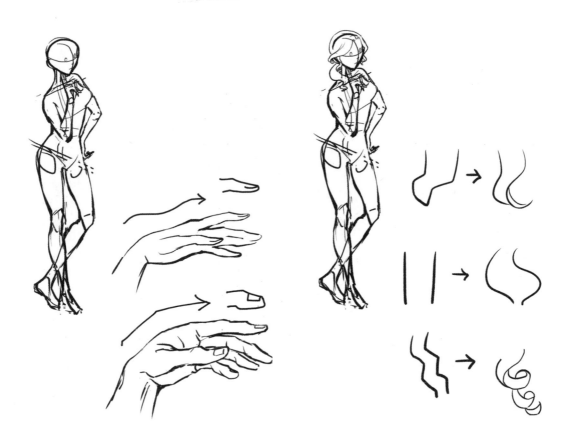

Step 3

Even hands show a gender difference. Female fingertips are thinner towards the ends while male ones remain the same thickness. Nails guide which way the palm is facing. Be careful not to add too many wrinkle lines, unless you are drawing aged characters.

Step 4

It is possible to depict texture and thickness of hair in simple lines. Do not draw directly on top of the skull lines, let the hair have volume. Soft and touchable hair should be drawn in a curve and have a natural flow. Here are some examples of techniques.

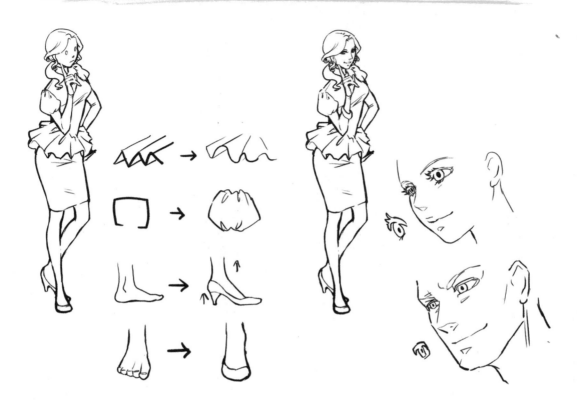

Step 5

Here you can see a range of texture and shape in the clothing. Pleats and tucks create the fluffy skirt and puffy sleeves. Heeled shoes have a unique shape and impose that on the foot. Once you observe and understand these things, you can draw any kind of outfit.

Step 6

Facial features are particularly important to depict personality. To get across how you as the artist feel about your subject and what you want to express, take care to emphasize the features that create character. The two face drawings are juxtaposed for an easier comparison of gender differences.

Quick Tip: Sketch people around you every day and refer back to your sketchbook when you need inspiration or information to get a pose right.

Step 7

Please limit how much **shading** you are going to add to the drawing. It should not be too much, unless you want to express a darker theme. Here you see the majority of the shading is done only under the jaw and on the ground at the subject's feet.

Step 8

Look at the male leg for reference. Once you understand the gender difference, you can try drawing the body at a different angle. Let's turn them round, look from above, and try different poses.

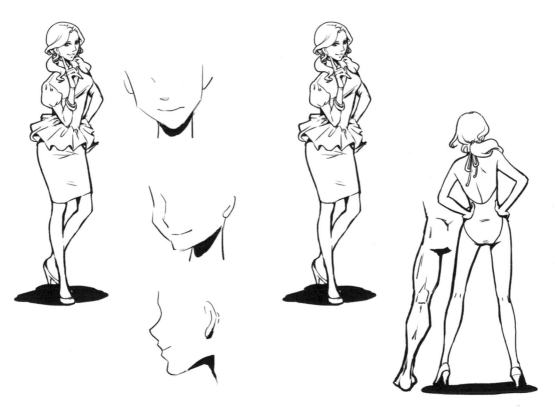

Artist Info: Images © Inko. Website: www.inko-redible.blogspot.com

TEENAGERS
BY BRUCE LEWIS

Step 1

Our exchange student kindly allowed me to use a picture taken in our den for reference. I started out by doing an off-the-cuff freehand sketch, without using the photo for reference. It ain't bad, but it's certainly less than good; it's too cartoony and stylized, for one thing. Time to give the photo a closer look.

Step 2

Here is the result. While I get a better image by looking at the photo as I draw, it's still no good: the proportions are off, and the positioning of the head and limbs is wrong. Back to the lightbox for another try.

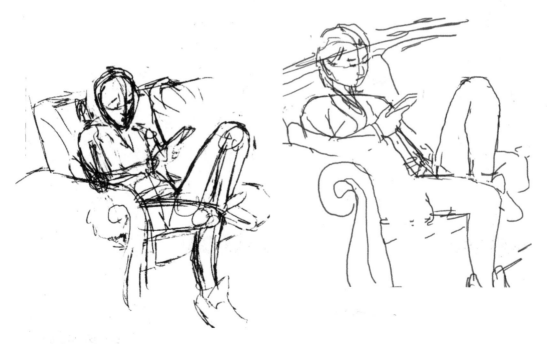

Quick Tip: To experiment with poses in three dimensions, you can buy a small, inexpensive wooden jointed model in a craft store and use it to sketch from.

Step 3

I want to establish correct proportions and positioning from the photo, but the answer is *not* to trace. Traced photos, whether traced on a lightbox or by computer, have that 'traced', fake colouring-book look. The reason is that the camera lens distorts the image's perspective and depth-of-field. It does not matter in a photo print, but if you trace it onto a piece of paper with lines it looks funny.

So instead of tracing, I measured out the model's image in terms of **head-lengths** to ensure correct proportions, then established a **reference grid** of lines in order to keep the positioning right.

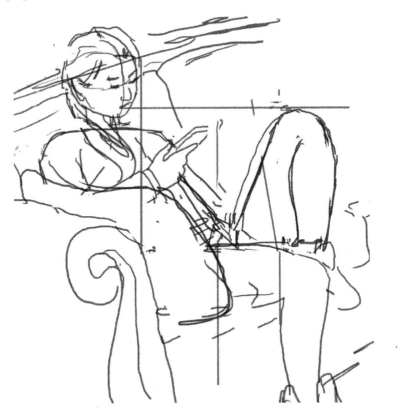

Step 4

Now we're getting somewhere! Using the grid and measurements to fix the pose, I'm able to generate a first approximation of a good image. I still have a way to go, but now that the pose is OK I can rough in the couch and tighten up the details somewhat.

Step 5

I've got things to the point where I can begin positioning folds and hems and such. Both the fabric of the model's tracksuit and the heavy leather upholstery are rather thick and stiff, so the angles and intensity of the folds are different than they would be in thinner materials.

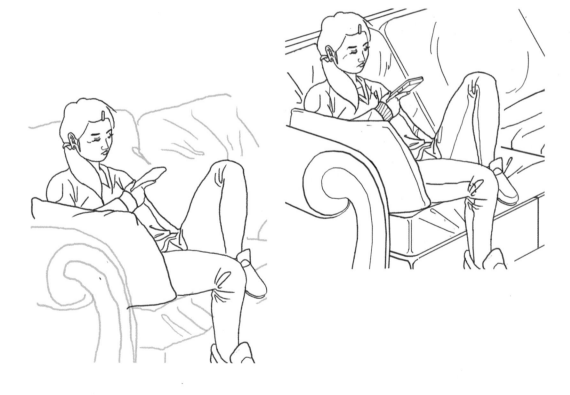

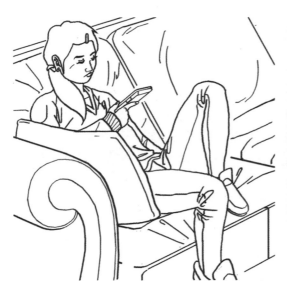

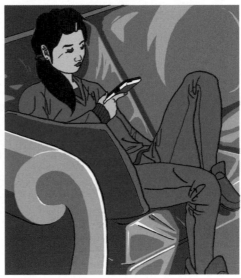

Step 6

I'm now satisfied with the quality of the line art. I had to rework the raised knee a bit (what happens to the joints, musculature and fat of the human leg when it is folded double is strange and best understood by careful observation), but with the final details added and the pose tweaked I'm ready to lay on some colour.

Step 7

Since this is a bold, 'liney' image, I decided to colour it with **bold blocks** of flat colour rather than shade it dimensionally. The result is a kind of Nagel-meets-Japanese-print look that I rather like.

Artist Info: Images © Bruce Lewis. Website: www.brucelewis.com

DRAWING BABIES
BY LEA HERNANDEZ

Step 1 - Proportions

Many artists draw babies wrong: like tiny people with adult faces. Newborns are about four-heads tall, with short arms compared to an adult, and their eyes, nose and mouth are close together and low on their face. Many appealing cartoon characters are proportioned like babies.

Step 2 - Appeal

Usually, babies are pretty roly-poly, without a lot of definition between their neck, wrists and ankles because of body fat. Babies' eyes seem huge because they have little heads! (You're born with the size of eyes you'll always have!)

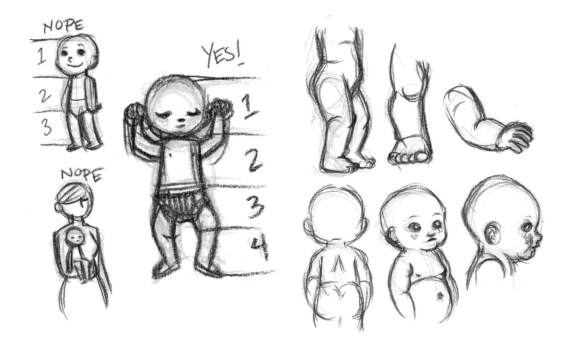

Step 3 – Hair

Babies can be either as bald as an egg past their first birthday, or be born with a lot of hair. Then there are the characters whose hair is fine, long and goes all over the place.

Step 4 – Lying and Sitting

Newborn babies and infants lie on their backs and tummies and hang out watching the world. Once their back muscles develop, they learn to sit up, leaning far forward to stay balanced – and sometimes tipping completely over because of that!

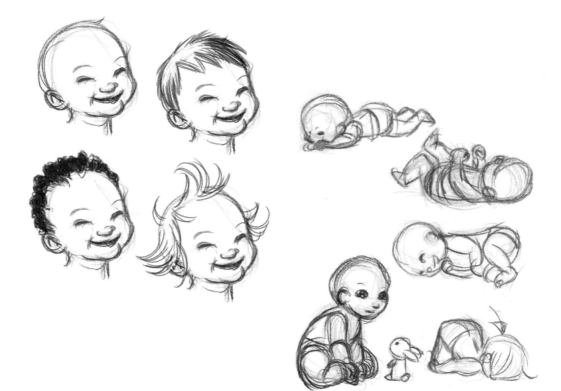

Quick Tip: Babies can't hold a pose or an expression, so sketching them from life is a real challenge for beginners. You might want to take photos or a video for reference.

Step 5 - Crawling

Crawling babies pull themselves with their arms, and push with their feet, using opposite limbs. They'll also lift themselves way up on their arms, like the Snake pose in yoga. After that, there is hands-and-knees crawling.

Step 6 - Expressions

Babies' emotions change by the second, and it all shows on their faces. Make the time to observe them in videos or photographs.

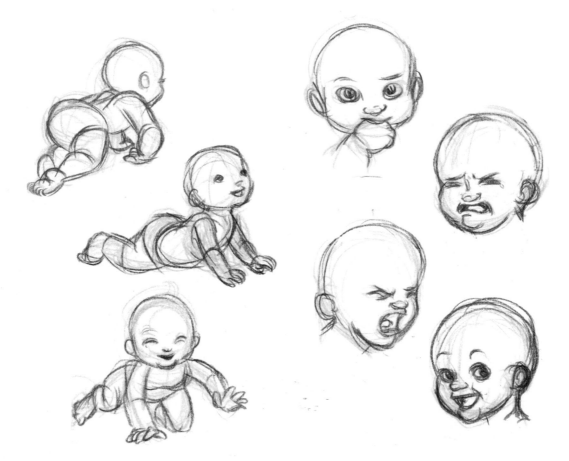

Artist Info: Images © Lea Hernandez. Website: www.divalea.deviantart.com

TODDLERS AND SMALL CHILDREN
BY LEA HERNANDEZ

Step 1 - Toddlers

When babies become toddlers, their heads are smaller relative to the rest of their body. They're five-heads or so now, and a 12-month-old is, on average, 76 cm (30 in) tall. Their features are beginning to move up their face a bit.

Step 2 - Walking

Eventually babies' legs and arms get stronger and they get tired of their view of the floor and start to pull themselves up on things. Their legs bow out, and they wobble back and forth a lot. When they walk, their arms are always out for balance.

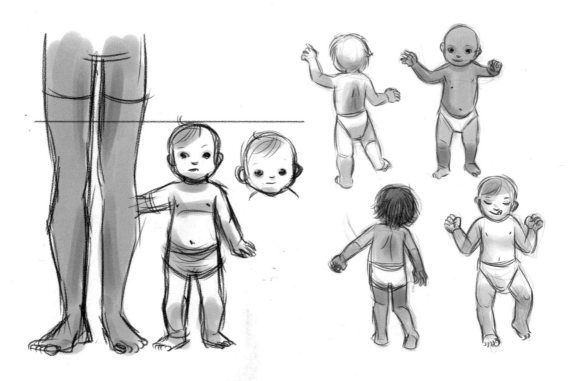

Step 3 - Comedians

Because they can move on their own, toddlers and small children sleep in hilarious and unlikely poses, and will 'crash' in their food, clutching a toy, or between the floor and chair.

Step 4 - Pre-schoolers

Three-year-old pre-schoolers are around 91 cm (36 in) high – half the height of a 1.8 m- (6 ft-) tall adult! Their eyes are at about the halfway point on their head. A pre-schooler can have pretty long hair by now if they've never had it cut.

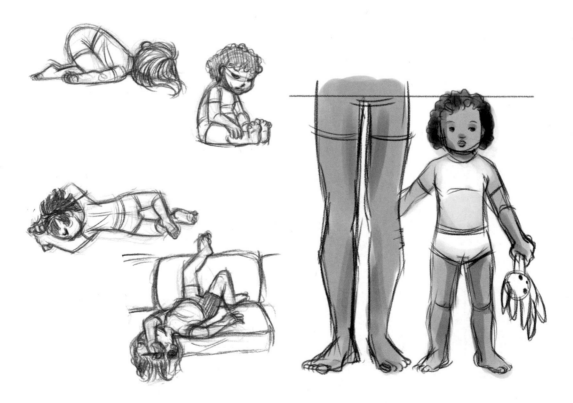

Step 5 – At Kindergarten

Five-year-olds are six-heads tall, and generally less round than pre-schoolers. They're about 107 cm (42 in) high, which means they're as high as a 1.8 m- (6 ft-) tall grown-up's bellybutton (unlike what you often see in comics and cartoons where children are drawn much shorter).

Step 6 – Primary School

Finally, at eight years of age, a child is about 1.2 m (4 ft) tall, and will be as high as a 1.8 m (6 ft) grown-up's chest. In all your drawings of kids, remember to use good strong gestures and posing to make them expressive.

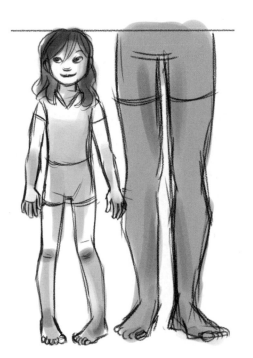

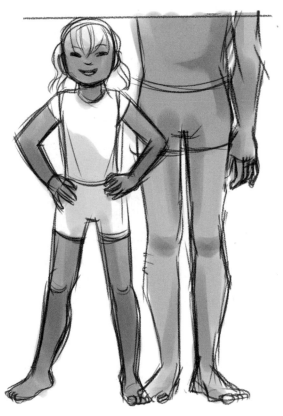

Artist Info: Images © Lea Hernandez. Website: www.divalea.deviantart.com

DRAWING OLDER PEOPLE
BY BRUCE LEWIS

Step 1

When drawing older folks, the basic factor to remember is gravity. Bones weaken, discs slip, flesh sags, feet go flat. The seven-and-a-half-head figure of the mature body declines to **seven-heads high** (or less!) as the person grows more stooped. Gravity does a number on the muscles and skin, too.

Step 2

Let's look at the effects of aging on a face. Here's a quick sketch I did of the poet Robert Frost in his youth. My, he's handsome. Firm chin, high forehead, smooth skin, and large eyes.

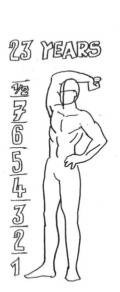

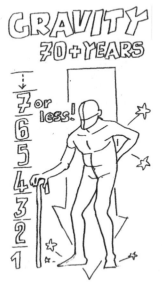

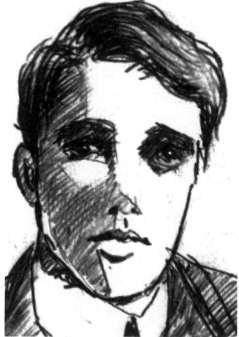

Step 3

Here he is many decades later. The chin is still firm, but underneath it are wattles of loose skin. His forehead now extends to his scalp thanks to hair loss, but the brows are impressively pronounced and bushy. His face is more creased and weathered.

Step 4

As the body ages, the bones go askew. Here is a simplified sketch of the skull of a mature adult. Notice the high forehead and overall vertical dimension. The *maxilla* (upper jaw) is long and tall, as is the *mandible* (jawbone). The teeth are long and straight. As skulls go, this one's looking good.

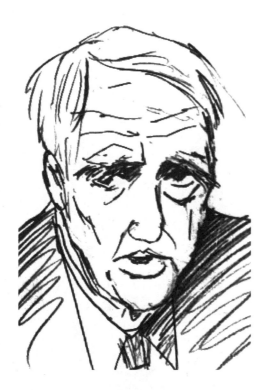

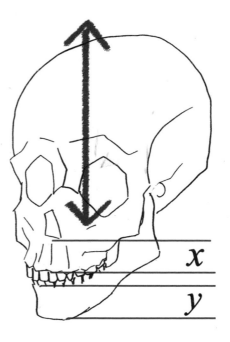

Quick Tip: When depicting the elderly, remember that gravity is dragging the facial muscles, skin and fascia down.

Step 5

What a difference six decades make! The skull has become longer horizontally and shorter in the vertical; the forehead slopes. The teeth are all gone and their supporting bones have been absorbed, widening the side-to-side width of the jawbone and causing the chin to shorten vertically and jut horizontally.

Step 6

A vivacious, attractive older lady. Still pretty, even though there are many lines around the eyes (laughter lines and crow's feet) and the mouth (creases). (Did you know there are medical names for all those wrinkles, such as the 'jugal furrow' or 'concentric eyelid furrow'?)

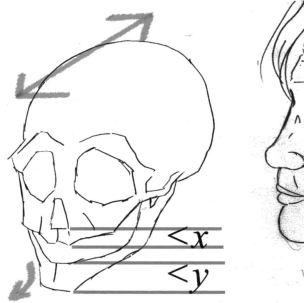

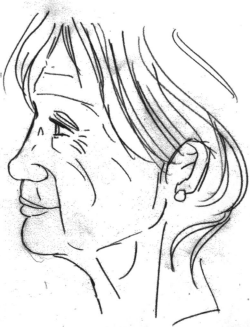

Quick Tip: Seniors today can be active and involved in life, so be creative when you draw them. If you don't know any elderly people, observe or use stock photos for reference.

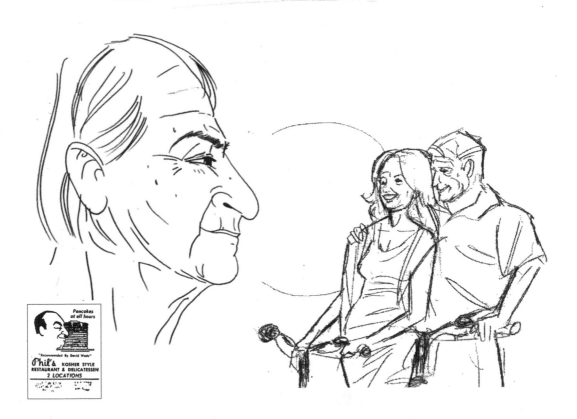

Step 7

A nice, well-kept older gent, whose face I drew from a stock photo but who is also a dead ringer for the late Phil Miller, who ran a delicatessen in Dallas (see inset). You see the elongated skull, sloped forehead, protruding bushy brow, turkey neck and wrinkles, all signs of gravity working its magic.

Step 8

Keep the effects of aging in mind: the stooped posture, the bagginess of the eyes, the changed jaw shapes, and the knobby quality of the various joints. Skin can be taut, slack, porcelain or wasted in appearance, but is in general much rougher and more weathered than a younger body.

POSES

You've already started drawing poses as you explored different body types. Each pose can be broken down into simple shapes, adjusting proportions as you work.

HALF-LENGTH PORTRAIT – OLDER WOMAN
BY CHIE KUTSUWADA

Step 1

Always start with a rough sketch to plan your drawing. Here I decided to draw a 40-something middle-class woman. A typical, nice motherly type, she is slightly chubby and softly smiling. In order to realize these ideas, I think about her facial expressions and pose to start with.

Quick Tip: A key thing to remember about drawing wrinkles is that they do not appear randomly but rather only round distinctive facial muscles.

Step 2

Next I draw a more detailed rough, remembering that the older person usually has a less defined face and bodyline. I think about what kind of clothes this kind of person would wear.

Step 3

I start inking from the head. Using rounder lines makes the subject look soft and feminine. The chin line is less sharp than in a young adult. I assume she is wearing some make-up, so the eyelashes are defined slightly more than usual.

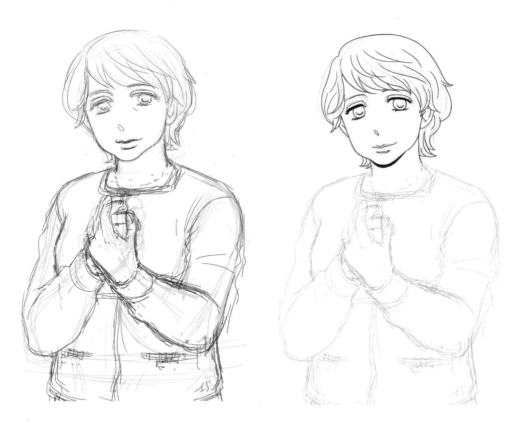

Quick Tip: Using screentone can give texture and dimension to a drawing very quickly. You can buy sheets of tone to use on physical art, or download digital tones to use on your computer.

Step 4

I now add the facial wrinkles. I usually start with the under-eye wrinkle; then, if I think the character should look a bit older, I add a line by the mouth. The numbers show the order in which I add wrinkles one by one.

Step 5

Inking continues onto the body. Since this character is supposed to be slightly chubby, I use **soft, curvy lines**. The bodyline is less defined, so her shoulder is rounder and the whole body shape is less hourglass.

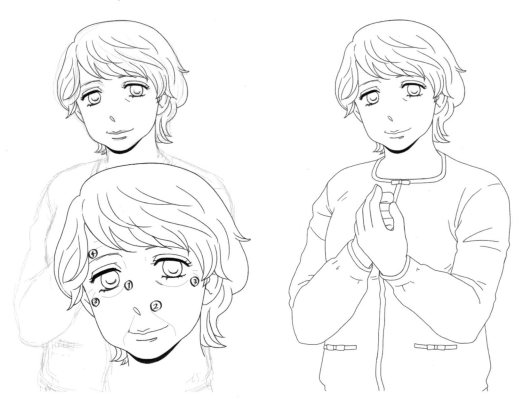

Quick Tip: One line makes a big difference, so it's a good idea to add wrinkle lines one by one. More and longer wrinkles make your subject look older.

Step 6

Next, I add some details, in this case accessories and jewellery. The wedding ring shows that she is married and adding nice accessories shows that she takes care of her appearance. Adding this kind of detail is like character profiling, and is important to give richness to your drawings.

Step 7

Add **tones** and **highlights** to complete the image. To highlight the eyes, I used smaller highlights than I would for younger characters. Eyes that sparkle brightly give an impression of being energetic and excited, which can be a bit too much for mature characters.

Artist Info: Images © Chie Kutsuwada. Website: www.chitan-garden.blogspot.com

SITTING POSE
BY BRUCE LEWIS

Step 1

You've probably never thought much about the mechanics of sitting. Frankly, neither had I, until I started drawing for a living. It's obvious that a figure is going to 'shrink' when sitting. But how? And by how much?

Step 2

The 'how' is easy: *folding*. The sitting body folds at the knee until the buttocks contact the seat of the chair (barstool, etc.), and folds at the hip in order to keep the upper body upright. The result is a controlled backwards 'fall' onto the seat.

How far? The rear end of the average, standing 1.7 m (5 ft 9 in) Westerner is about 0.9 m (2 ft 8 in) from the ground. The top of a typical chair seat is about 0.5 m (1 ft 6 in) from the ground. The body folds at the centre point of the knee joint about 0.6 m (1 ft 9 in) from ground level, bringing the behind into contact with the seat, a 'fall' of about 35.6 cm (14 in). The padding of the buttocks (A) and thighs (B) adds 6 cm (2.4 in) of height; the feet (C) spread apart. Total 'shrinkage' is therefore roughly 40.7 cm (16 in); the body is 1.4 m (4 ft 5 in) tall when sitting; 75 to 77 per cent of its standing height.

5' 9" (175,3 cm)

4' 5" (134,6 cm)

1' 6" (45,7 cm)

1
2
3
4
5
6
7
.5

Step 3

All of this just to say that if you estimate your sitting figure as being about 75 to 77 per cent of the height of the standing figure, you'll be in the right general range.

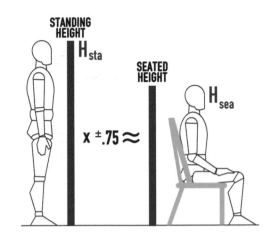

STANDING HEIGHT
H_{sta}

SEATED HEIGHT
H_{sea}

$x \pm .75 \approx$

Step 4

Some would have you believe that normal people sit all sprawled across the chair in a jagged, exciting line. In reality, most people slump straight into the chair in a sort of slouch. The line created thereby is much simpler. Need I say that neither pose is particularly fun to draw?

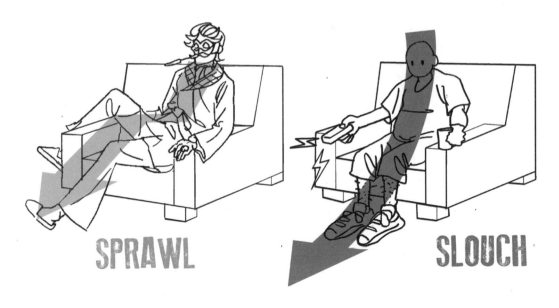

SPRAWL SLOUCH

Step 5

I found a woman to copy from a stock photo. First make a gestural drawing, that is, a very rough sketch made with sweeping lines. What you're aiming at here is to get the 'feel' of the pose, the overall line and balance of the body. Don't be afraid to make it messy.

Step 6

Now it's time to rough in the form. This is the stage where you rub out, redraw, and adjust until everything is the right size and in the correct position. Flip the paper over and do a light table check to make sure you're not drawing at an oblique angle.

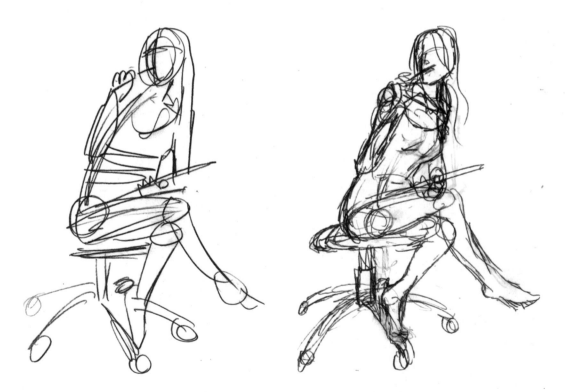

Quick Tip: Use 'landmarks' on the figure (e.g. the place where the line of the leg crosses the rim of the seat is directly beneath the end of her pencil) as guideposts for positioning and proportions.

Step 7

Put the rough on a lightbox (or tape it to a window) and draw the 'tight' on a separate sheet. You may need to do this several times, moving the top drawing over the bottom in order to fix location/proportion errors.

Once you have the basic form, draw in the details. Notice the effects of gravity on the figure as the body of the model squeezes against the relatively firm surface of the chair. See how her left thigh fetchingly spreads out a bit? That's because the entire weight of her right leg is on top of that thigh, compressing it against the seat cushion. This effect gives the whole figure a 'seated' feel. It is also cute.

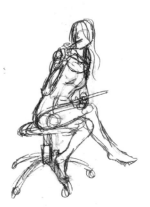

Step 8

In fact, the weight of the body distorts the entire figure when seated. This girl is 'swinging', that is, she has her weight on her left leg. The movement of her body to her left (blue arrow) produces a downward, turning force (green arrow) to her left. In effect, her entire body is trying to 'swing' around the pivot of her left hip and roll her off the chair!

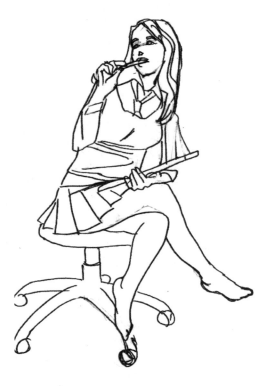

Quick Tip: When drawing the seated figure, keep weight distribution and gravity in mind and your seated figures will be dynamic in any pose.

Step 9

How does this 'swing' affect her figure? First, her head and hair (A) swing to her left as gravity pulls them down. The hair on a tilted head hangs straight down on the lower side and lies close against the head on the higher side. Next, it flattens her left thigh against the chair, as the downward force (B) produced by gravity places her whole weight upon it.

Finally, to 'swing' about her left hip she has to lift her left thigh, leg and foot above the floor; as you can see, she's got the toe of her right shoe on the deck in order to keep from rotating clockwise (C) back to a balanced sitting position.

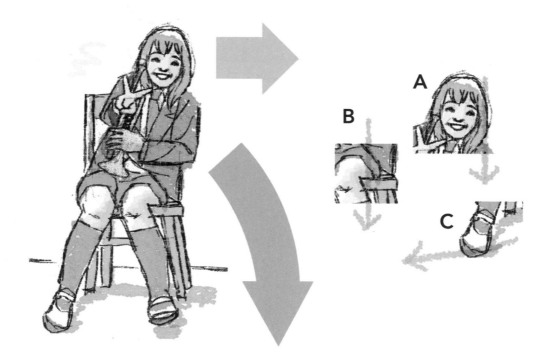

RECLINING POSE BY LAURA WATTON-DAVIES

Step 1 - Blue Line Structure

Character A is on the beach on a fold-out lounge bed, and character B is climbing into bed. These poses are roughed out and proportionally scaled by using the same circle that is their head. Each character is eight-heads tall. The rough sketch figure is to help with proportion and pose.

Step 2 - Red Line Body Form

The **blue 'bone' structure** can help compose the full body shapes when drawn on top. The red pencil body forms are drawn on top of the blue line 'bone' forms. At this stage it is also good to roughly draw the props surrounding the characters to get a good sense of presence and scenario.

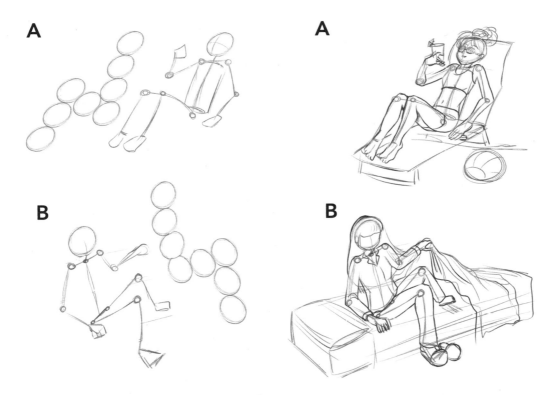

A

B

A

B

Character A is drawn with her spine slightly curved outwards. The anchor is her pelvis area and she reclines from this area, led by the head. The spine area connects the head with the pelvis and is drawn a little bit bent to emphasize the reclining action.

Character B is drawn with her hair swooping away from her to help give a sense of slight motion. This character is aiming her body towards the side. The head and mainly the shoulders are angled towards where the character is going to lie; she is going to put her head on the pillow guided by the shoulders. The pivot point is her pelvis.

Step 3 – Inks

Character A is now inked and the body has a few lines and creases where limbs fold (mainly elbows and knees). There are also creases in the lounge bed where the body and items sit, to show texture folds where objects impact. The material is a bit stretchy so strokes help emphasize the material texture.

For character B, one leg is up on the bed and the other will follow to propel the character

onto the pillow. The creases are around the middle of her waist, to show that she is also bending towards the pillow. There are also creases around the knees and elbows, too.

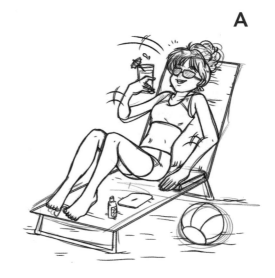

A

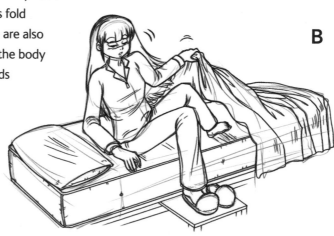

B

Step 4 - Green Lines

For both characters, the spine
could be drawn with more of a
swoop to emphasize a more
cartoon-like stance, or if the
character is moving even
more energetically in these
situations.

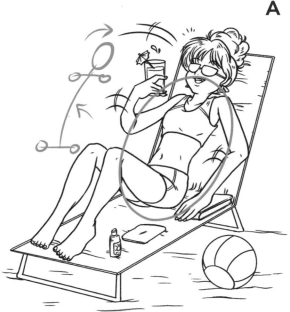

A

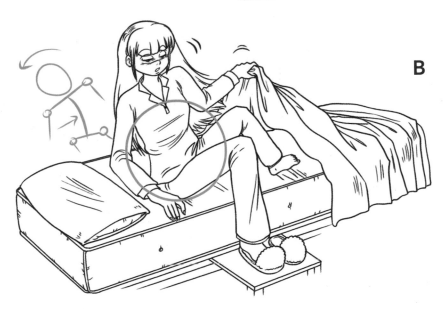

B

Step 5 - Motion Lines

As character A is inked, there are some lines added around the figure to give a sense of **motion**. There are also some smaller lines around character B. Smaller lines denote a smaller movement; longer curved lines denote a quicker pace. A person moving faster will also have a few extra objects moving around them as they are caught up in motion. Here, there are two drops of juice jumping from the cup.

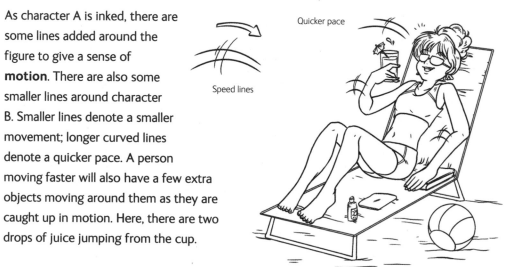

A

Quicker pace

Speed lines

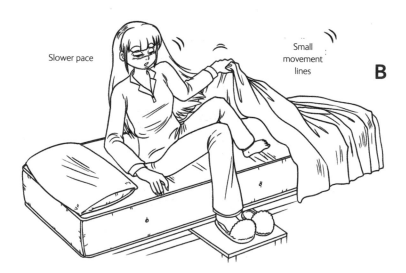

Slower pace

Small movement lines

B

Artist Info: Images © Laura Watton-Davies. Website: www.PinkAppleJam.com

Step 6 - Colour

A

Think about what your character will be doing in your drawing, and apply these ideas to your work. They may be stretching backwards in a yoga pose, so their body will crease around the middle of their spine. If your character is bending forwards, their stomach area will crease.

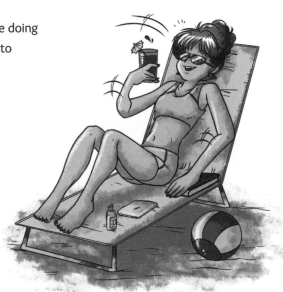

B

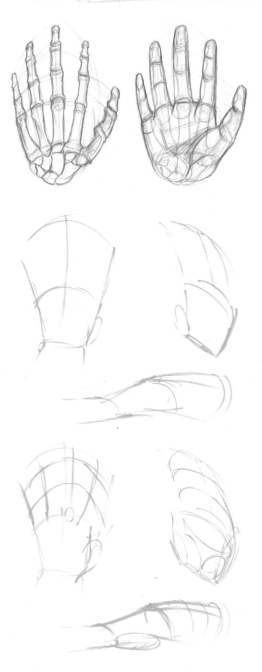

DRAWING HANDS
BY KAT LAURANGE

Step 1

Hands are wonderfully complex – and that makes them tough to draw! Have a look at the anatomy of a hand before we break this tough task down into simpler steps.

Step 2

Always build drawings up from basic shapes. Think of the palm as an **irregular rectangle**, curved across the top. The fingers project outward along the same plane as the top, or the back of the hand.

Step 3

Observe the **arcs** made by the knuckles; whatever position the fingers are in, the knuckles will align in these lovely arches. The top of the thumb aligns with the arch of the fingers' first knuckle.

Step 4

If the knuckles create an **arch**, the fingers are like a **fan**. Draw through for correct placement on the bits that overlap. Note the **boxy** shape of the wrist.

Step 5

The fingers, like the main body of the hand, are flattish on top and curved along the bottom. Contrasting **angles** and **curves** in this way makes for a more pleasing drawing.

Step 6

Some more views. Note the curve of the fingers when the hand is relaxed. You can use **ovals** to delineate the placement of the finger segments when the fingers are curled, as in a fist.

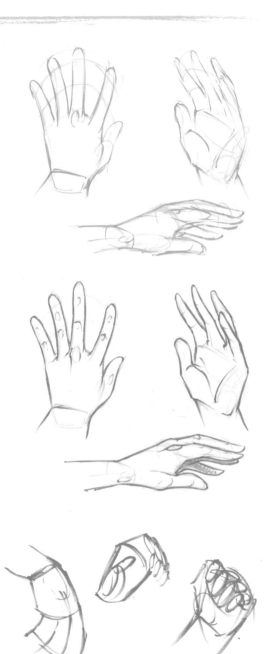

Step 7

Note the wrinkles in the wrist where the flesh compresses, and the flatness of the top of the hand. The tops of the fingers also are bonier, contrasting with the softer flesh of the bottom, denoted by curved, overlapping lines.

Step 8

Although all hands have the same basic structure, individual hands are distinct. Men's hands tend to have blunter fingertips and more pronounced knuckles, while ladies' hands are more smooth and curved. Children's hands have shorter fingers.

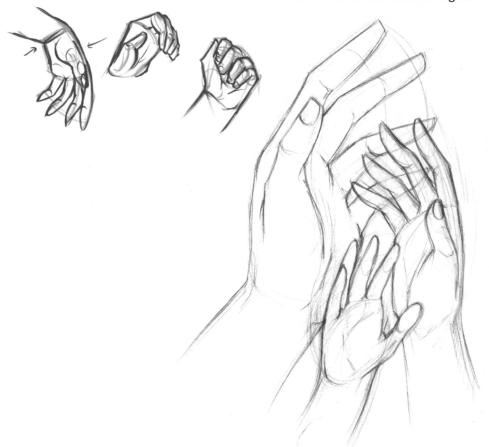

OLDER HANDS
BY LAURA WATTON-DAVIES

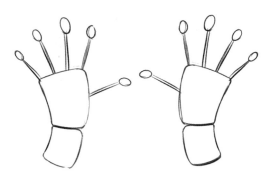

Step 1

The structure of a hand can be roughed out using **matchstick** shapes for fingers and boxes for palms. Giving the flow of the hand a little bend will also add a bit of dynamism to a static pose.

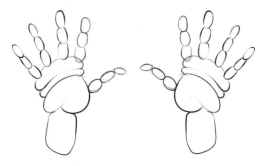

Step 2

Structure of the ligaments and muscle can be drawn roughly by laying down **ovals** and **balloons** to give shape to your structure. These are good for cartoony hands; you can study anatomy books or draw from real life for the next level.

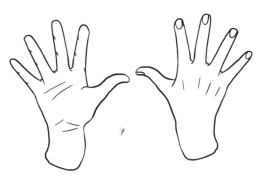

Step 3

The front and back structure of a younger person's hands. Note the small lines and **creases** to give the impression of smooth skin. There are some creases on the palm to imply where the hand will bend. In comparison to ...

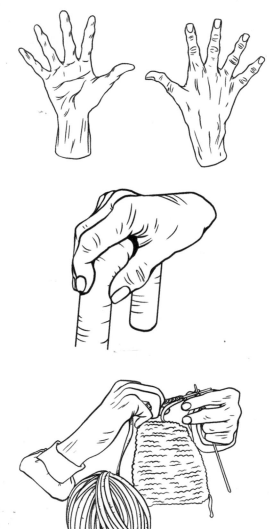

Step 4

... a much more elderly person's hand. You can compare the weightier knuckles where joints are more enlarged than the skin around the bones in the finger; extra lines have been added to show where some skin will sit heavier than on other places, too.

Step 5

Here is an older person's hand, lightly gripping the rounded handle of a walking stick. Wrinkles are more prevalent on the areas of hand where the knuckles lie and where digits have flexibility.

Step 6

Some elderly people are still incredibly nimble. This image shows a few extra wrinkles again by the knuckles and flatter areas of the hand, and a rounded joint or two on the fingers, but not too many.

Quick Tip: Older hands and feet have more wrinkles, bumps and raised veins than those of a younger person, so use highlights and shading to show their character.

Step 7

This is a **digitally coloured** image that shows a simple colour selection. The skin shows some lumps and bumps, which have been highlighted with the colouring style. There are highlights on row after row of the knitted square to give the wool its texture.

Step 8

This is another digitally coloured image, which again emphasizes the colouring style where **highlights** have been left over the wrinkles to draw attention to the surface of the skin. The wooden cane has been given a simplified wooden texture by using similarly patterned highlighted areas to create the grain.

Artist Info: Images © Laura Watton-Davies. www.pinkapplekam.com

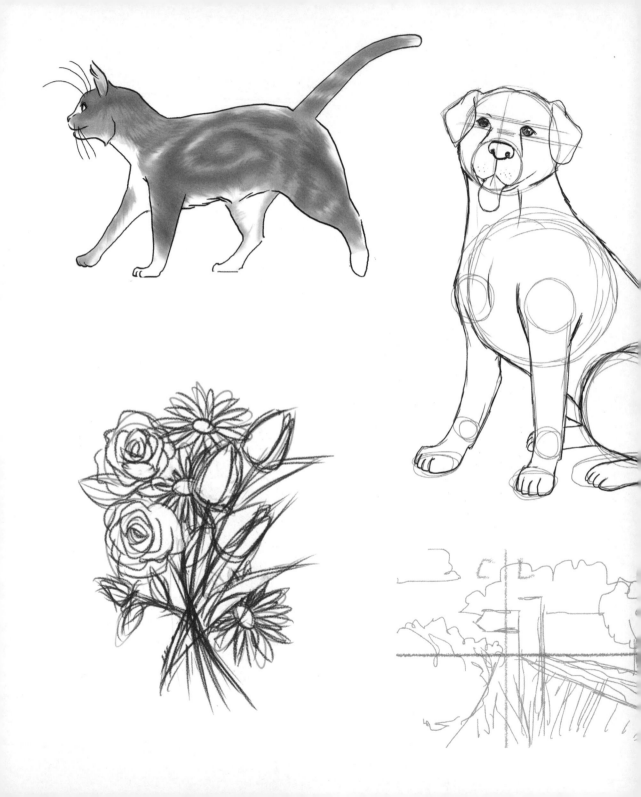

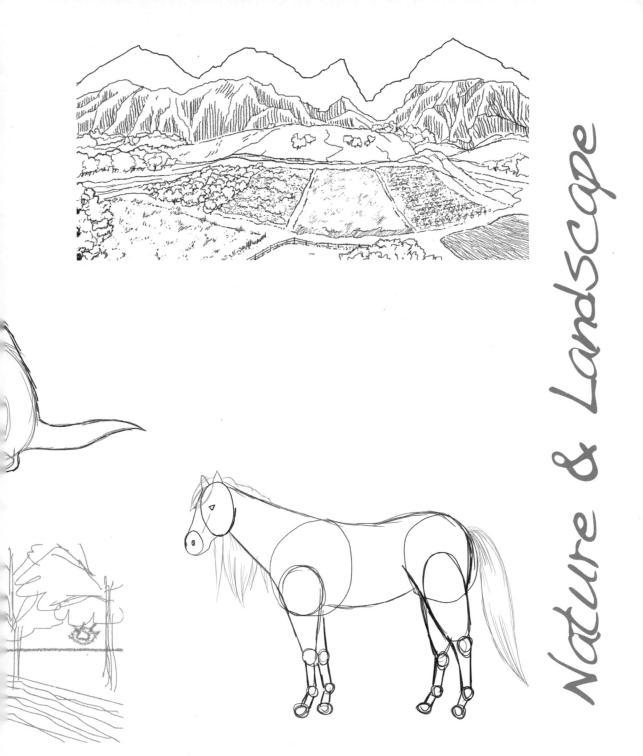

ANIMALS

There are so many different animals that you could work your way through a whole library of specialist books and hours of online tutorials. To practise, let's focus on three animals that can be seen in many rural and urban settings – dogs, cats and horses.

DOG 1
BY KRISTEN MCGUIRE

Step 1

Break the dog down into shapes. For a Labrador in the sitting position, the dog can begin as three large circles. Remember to sketch lightly when laying out shapes and guidelines.

Step 2

Go ahead and sketch a smaller circle for the dog's muzzle and add in guidelines for his eyes. His ears are a triangle shape.

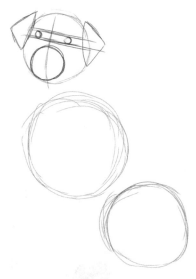

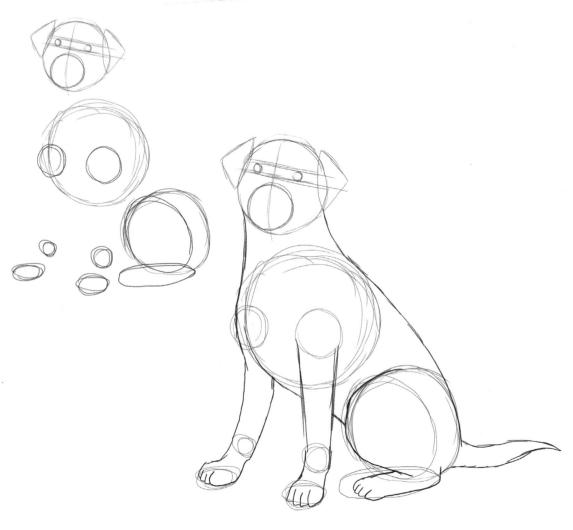

Step 3

Continue to break the dog down into to shapes by sketching out circles for his shoulders, wrists and paws. For the back legs I used more of an oval shape since he is sitting.

Step 4

Now start connecting lines between all of your base shapes. Our Labrador is slowly starting to take shape!

Step 5

Now for the fun part, we get to start adding details! We'll start with his head. Make his eyes oval shaped and add his snout. Having his tongue hang out makes him seem extra happy.

Step 6

Finish filling in the details. Use **short strokes** when outlining the body and legs to get that furry look. Don't forget to add in that other back leg!

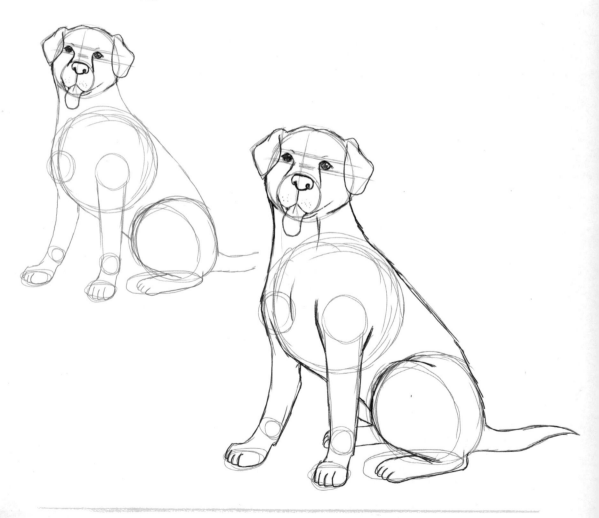

Step 7

Gently erase your guidelines and voila!
You have a finished, happy-go-lucky
Labrador.

Step 8

Adding colour will help bring your dog to
life! Naturalistic fur is never just one colour.
Aim to put at least **three shades** of the
main colour into the fur – pale, mid and
light – and add highlights in silver or red
and lowlights in black or dark brown.

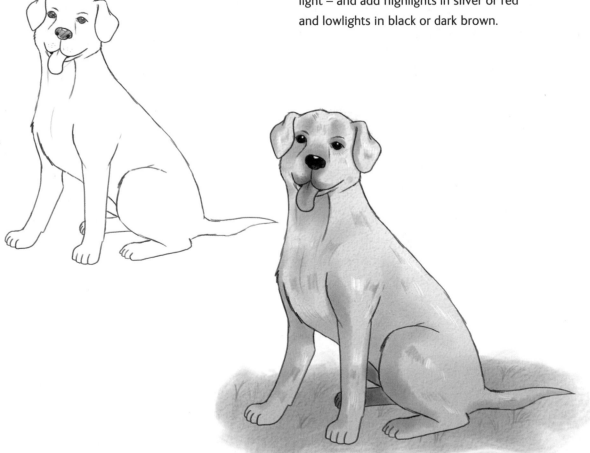

Artist Info: Images © Kristen McGuire. Website: www.kriscomics.com

DOG 2 BY EMMELINE PUI LING DOBSON

Step 1

I begin to plan my drawing by researching the breed of dog – in this case, an American Akita – that I wish to depict. This is a process of studying the breed's proportions and skeleton, researching online and referring to a book on animal anatomy for artists.

Step 2

I want to emphasize my subject's large build and adorable face. I go out with my digital camera looking for settings that will give the viewer a **point of comparison** for the dog's size. The photo I like best allows the dog to be moving down some steps towards the viewer in the final composition.

Step 3

Using what I've learned about the skeleton and musculature of the Akita, I make several sketches, working out a final pose, and how the subject will fit in the chosen environment. I've decided to place an empty bottle in the picture for scale, compositional balance and a gritty urban mood.

Step 4

I adore the texture and richness of **conté crayon**, and through making these studies I decide that I'll use just a minimal amount of colour in the final drawing. The study on the right settles the pattern and colour of the dog's coat.

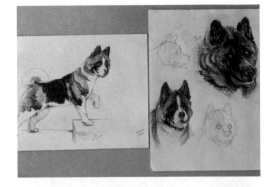

Step 5

I've selected a **mid-grey tone paper** on which to execute the final drawing. Here's the page taped to my drawing board, my study sketches nearby, and some test scribbles with white ink and conté crayon in the ruled margins. In faint F pencil, I've sketched the composition onto the page, ready to begin applying conté crayon.

Step 6

Starting with the lightest tones in the composition, I start using **white conté crayon** to lighten the page. Referring to the photograph I've chosen for my background, I try to make sure each wall and floor surface is a matching tone to the lightness or darkness of each facet of the built environment I can see in the photo.

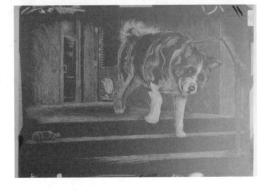

Quick Tip: Using **conté crayons, pastels or watercolour pencils** gives a range of different textures to your work that can really enhance pictures of animals. As you get more confident with basic drawing, try out different media to see what suits your style and the subject matter.

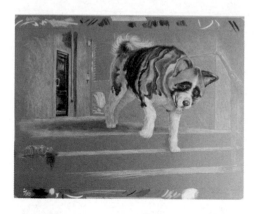

Step 7

Once I've worked from the lightest parts of the composition to the same mid-tone as the page, I take a black stick of conté and start applying this rich colour where I see dark areas in the photo and my reference drawing of the dog. With a terracotta colour I add **warm accents**, imitating the texture of fur with the strokes of the medium.

Step 8

As I work the drawing to final quality, I pay attention to the texture of the dog's coat, and ensure the relations between each area in terms of light and dark are as accurate as possible. There is a subtle accent in a pale pink colour on the dog's snout and tongue.

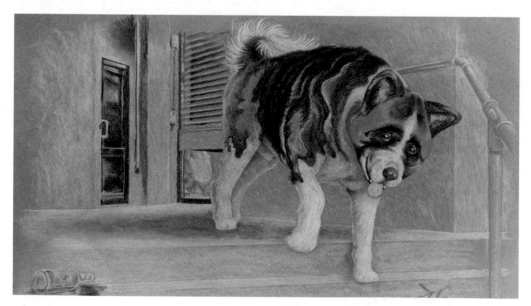

Artist Info: Images © Emmeline Pui Ling Dobson. Website: www.emeraldsong.com

CAT 1 BY EMMELINE PUI LING DOBSON

Step 1

I made these studies of lynxes and draft compositions to prepare for this piece. Sometimes I use ultra-scrappy 'sketchbooks' made from stapled paper; this makes me feel less precious about initial sketches, so I produce them faster. It's good to throw away early ideas while coming up with more ideas.

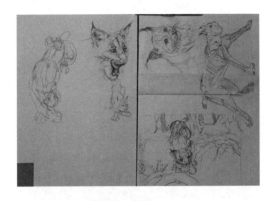

Step 2

During my initial sketching process, I get an idea for the final pose of the lynx and what kind of environment would complement the pose. I took these photos in the New Forest and combined them on my laptop to mock-up a background reference image.

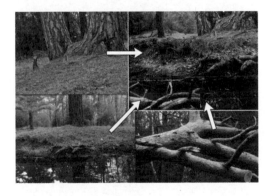

Step 3

I found a lot of available reference photographs for lynxes online. By this stage I knew I was being ambitious with the posing and the setting, so I sifted through collected reference material to find pictures that matched closely to my design's face, pose, and environment.

Step 4

I prepared my workspace for drawing to begin, faintly pencilling guides onto the page with a hard F pencil. I decided to work initially with the dark tones of the image. (For the American akita project also in this book, I chose to work on the lightest tones first.) As I am left-handed, I work from right to left, which minimizes the risk of smudging the **conté crayon** with my hand.

Step 5

I started experimenting with **adding white** where I intend to pick out elements of the picture. I am working around the lynx, thinking about how the colours just next to the cat's body will contrast with the fur.

Step 6

I've added a lot of grey to the page to mask the warm colour of the paper. This drawing is designed to complement that of the American Akita, which uses a **terracotta accent** colour. Since this drawing is executed on a terracotta coloured page, I need to dial the colour back.

Quick Tip: To avoid smudging your work, try working 'backwards' – left to right if right handed or vice versa – and keep a scrap of clean paper under your drawing hand and wrist to avoid touching the paper.

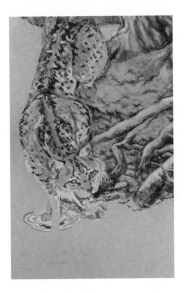

Step 7

Working closely from the selected photo reference, I carefully draw the different coloured markings that feature on the lynx's face and body fur.

Step 8

Continuing to work from right to left, I finish the background surrounding the lynx. As a final touch, after spraying the page with **spray fixative** for media like charcoal and conté crayon, I use a **fine brush** and **Deleter No. 2 white ink** to add the lynx's whiskers.

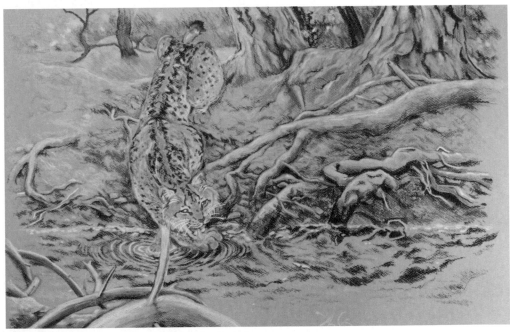

Artist Info: Images © Emmeline Pui Ling Dobson. Website: www.emeraldsong.com

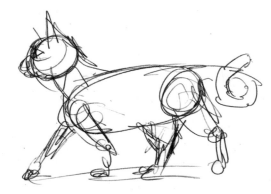

CAT 2 BY BRUCE LEWIS

Step 1

Cats are pretty much standard-issue mammals: spine, bony skeleton, fur, muscle, etc. Just use the ball-and-cylinder method, same as you do when sketching people. The best way to get started is to just rough out your basic cat shape, as I have done here.

Step 2

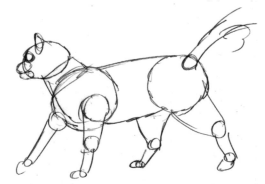

If there's one word that describes pretty much every cat, it's 'alert'. Sure, they sleep a lot, but it's an alert kind of sleep. Keep this alert nature in mind as you fill out your base sketch using the lightbox. Everything should look perky and have that ready-to-pounce feel.

Step 3

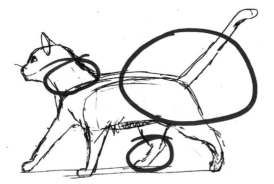

Whoops! I see some mistakes. The cat's neck is too short. The neck of the average cat is hidden behind a thick ruff of loose skin and fur that makes the neck look thicker and shorter than it really is. The rear leg is too short and close to the belly. The cat's butt is too low. It should be more or less level with the cat's eye. To the lightbox...

Quick Tip: Build up fur in light, feathery pencil strokes to draw a really fluffy cat. Heavy solid shading works better for cats with short flat coats.

Step 4

Okay! The neck is fixed, the belly/leg relationship has been corrected and the butt is back where it ought to be. Best of all, this cat has that saucy, alert cat-itude that real cats have. I think we're ready to go for the finish!

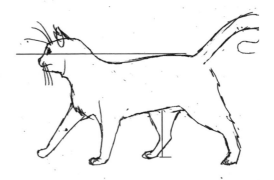

Step 5

My first attempt at finished line art comes out looking pretty good but there are definitely still some problems with proportion. The neck still isn't quite right, for one thing, and I'm pretty sure the left rear leg and foot are wrong. Let's try again.

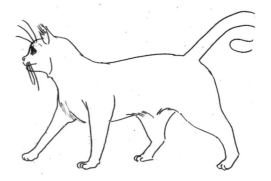

Step 6

The 'shoulders' are wrong. A cat's front limbs are designed to operate in a horizontal 'leg' orientation rather than as arms. As a result, cats do not have a chest as we know it; their front feet are much closer together at the shoulder than are our arms. I've redrawn Kitty to reflect this difference, and I've also fixed that back foot.

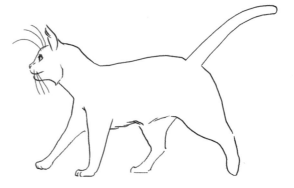

Quick Tip: The more time you spend observing cats, the better your next cat drawing will be.

Step 7

With the anatomical quirks fixed, and a couple of coats of **two-tone** fur applied, this is much better. I coloured Kitty using two shades of orange (smeared together to form a fur-like texture) and a little bit of white on top.

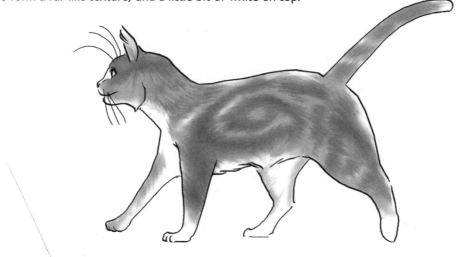

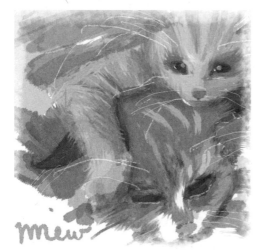

Step 8

Spend time observing cats, carefully noting things like the direction their fur grows on different parts of their bodies, the way their joints do (and don't) bend, their typical postures, etc. Study them, then draw what you see; not a *symbol* of what you see.

Artist Info: Images © Bruce Lewis. Website: www.brucelewis.com

HORSES
BY KRISTEN MCGUIRE

Step 1

Break the horse down into shapes. Go ahead and draw a circle for his head. Lightly sketch two larger circles for the horse's chest and rear.

Step 2

Let's fill in some details on the horse's head. Add two triangles for the ears. Add a second circle for his muzzle and connect the jaw to the muzzle. Draw in the eye. (The other eye is not visible to us.)

Step 3

Continue to break the horse down into shapes by creating circles for the joints in his legs. For his back legs, I used more of an oval shape since it fits closer to the actual shape of a horse's back leg. Draw circles for his hooves.

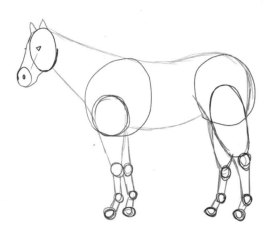

Step 4

Now start connecting lines between all of your base shapes. Our horse is slowly starting to take shape!

Step 5

Now we need to add a tail. To make it a bit more realistic, draw the hair in a clump and add lines for detail. Do the same for his mane.

Step 6

Finish filling in the details. Make the hooves a blocky triangle shape and add definition lines for the muscles.

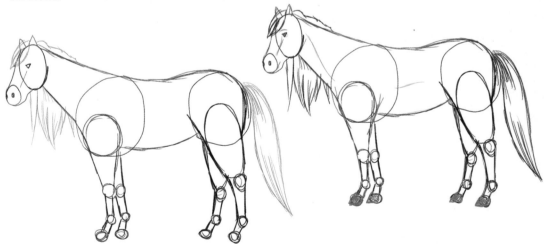

Quick Tip: This is a good point to check that you've got the proportions right. Some horses have long backs, short necks and so on. If you want a fat Shetland pony, for example, the legs will be shorter and the body rounder.

Step 7

Gently erase your guidelines and now
you have a finished horse!

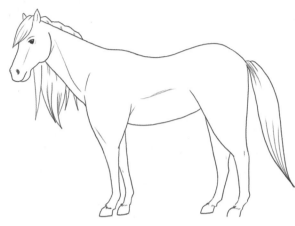

Step 8

Adding colour will help bring your horse
to life!

Artist Info: Images © Kristen McGuire. Website: www.kriscomics.com

NATURAL SCENERY

The skills you need for drawing landscapes and settings are the same as for figure drawing – observe closely and make lots of sketches. But with so many different things in your picture frame, you need to practice organizing them so that they work together. Start with individual elements, like trees or flowers, and build them into a picture.

TREES
BY BRUCE LEWIS

Step 1

You may not realize it, but you could have the basic model of a tree in your refrigerator right now. You could go into the cold outdoors and sketch an actual tree, or go into a nice, warm kitchen and grab a stalk of broccoli.

Step 2

Like a tree, a stalk of broccoli has a fibrous, woody 'trunk', which splits into 'branches' with 'leaves' on the end. This sort of big-smaller-smallest arrangement is called a **fractal**. The thing to remember when drawing trees is that you start big (the trunk) and get small as you proceed outwards from it.

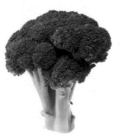

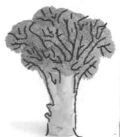
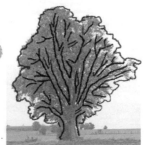

Step 3

Keep in mind that a tree is more or less the same shape above and below ground. The roots of the tree divide and grow smaller as they diverge from the trunk, ending in tiny 'root hairs' as their above-ground counterparts – the leaves – grow from branches.

Step 4

Starting out, you draw the big end of the fractal: the trunk. It starts out at ground level, tapering as it rises. The bigger branches, or boughs, shoot out of the trunk at various heights and angles.

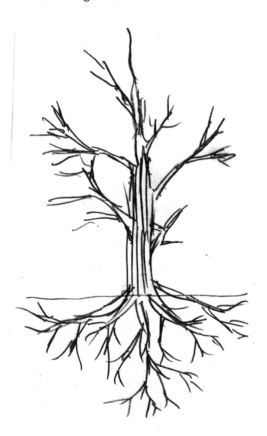

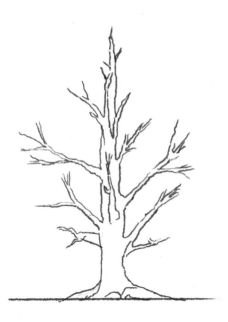

Quick Tip: These instructions are for drawing a typical deciduous tree (e.g., maple, elm), but the same basic principles apply to drawing conifers and other types of trees and large herbs.

Step 5

Draw in the smaller branches splitting off from the boughs, each with its own even smaller stems and twigs. Since trees are living creatures, give the boughs and branches a sort of jaggedy-rough appearance rather than drawing them as smooth cylinders – the further from the trunk, the more jaggedy.

Step 6

Sketch in leaves as a jiggly outline of 'puffs' around the branches. On this scale the leaves will be tiny, so you're meant to suggest the spreading leaves, not depict them. Don't be afraid to use a really free hand here, the more irregular the better. The 'puffs' of leaves on closer branches will overlap with those further away.

Step 7

Now go inside the leaf line and erase most, but not all, of the branches you drew. The puffs of leaves will hide the trunk and branches in the same way the broccoli's top hides its stalks. Do leave a few 'windows' of unerased branches to show through, however.

Step 8

The sides of the leaves and branches nearest the sun will be brighter than those in the shade. Using the side of your pencil, roughly sketch in the shaded sides of each 'puff' of leaves, then sketch in the **half-tones** (the sun-dappled areas in between light and shadow.) Make tiny curlicues, swirls, and loops to suggest the waving leaves of the tree. Get a good dark-to-light gradient on each 'puff'.

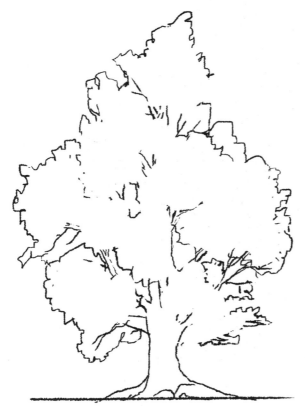

Quick Tip: Trees are almost never symmetrical, so stagger the boughs as you draw. Remember also that a tree has depth as well as height – draw some boughs facing towards and away from the viewer.

Step 9

Take the tip of your **eraser** and go over it all, subtracting graphite in small **swirls** to further 'leaf out' the tree. (The branches, boughs and trunk will mostly be in shadow, so darken those areas.) Go around the jagged outline of the tree and erase the line and bits and pieces of your shaded areas.

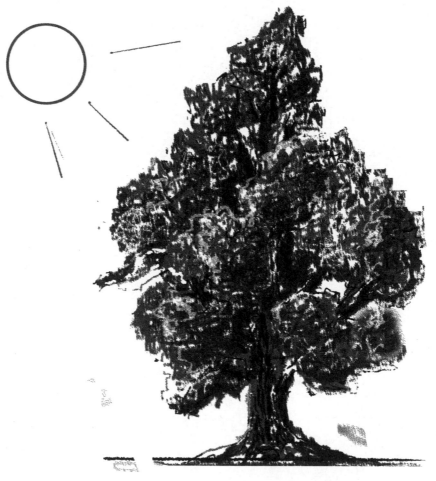

Artist Info: Images © Bruce Lewis. Website: www.brucelewis.com

FLOWERS
BY LEA HERNANDEZ

Step 1

You can draw every kind of flower, even very complex ones, with just four shapes: triangles, ovals, circles and spirals, plus lines to express curved, vining or straight stems.

Step 2

Many flower petals and leaves are oval, round or a rounded triangle and always have a 'pinch' at one end where they attach to the centre of the flower or the plant.

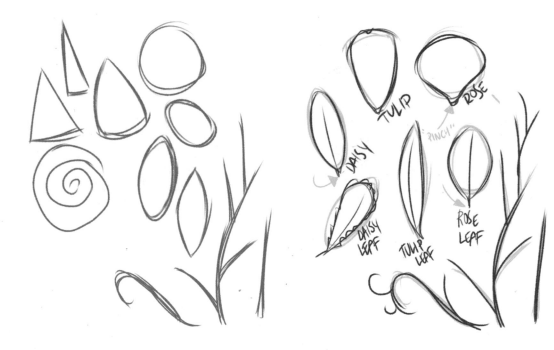

Step 3

Sketch in your flowers with light lines and rough shapes. Feel free to change your mind and explore ideas. The circles will be daisies, the triangles tulips, and the spirals roses. I like to use a textured pen in a digital drawing program from this point on.

Step 4

Take your favourite rough drawings and refine them some more, nail down sizes and begin to add details. Observe flowers in person and photographs. There are hundreds of different kinds of roses, daisies and tulips, not to mention over 300,000 other flowers.

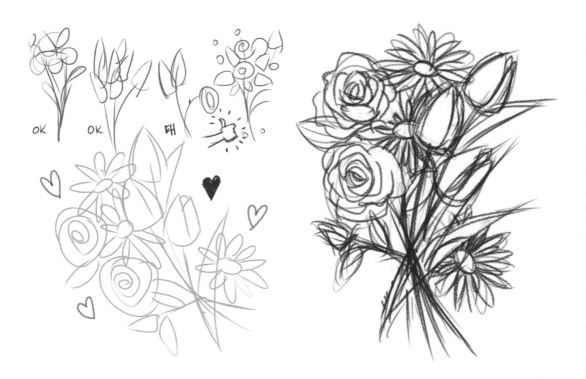

Quick Tip: You can make your own greetings cards very easily by scanning and copying your art. A bouquet like this makes a beautiful card.

Step 5

This where you 'tighten up' your drawing, adding fine details like the serrated edges of the rose leaves, the rosebud, the tulip petals, the extra petals on the daisy. Keep in mind that flower petals overlap one another.

Step 6

For inking, you can use a pen or a digital paint program. For colour, you can use bold, stylized blocks with textured brushes for a loose, fresh look, or for a more painterly and romantic look.

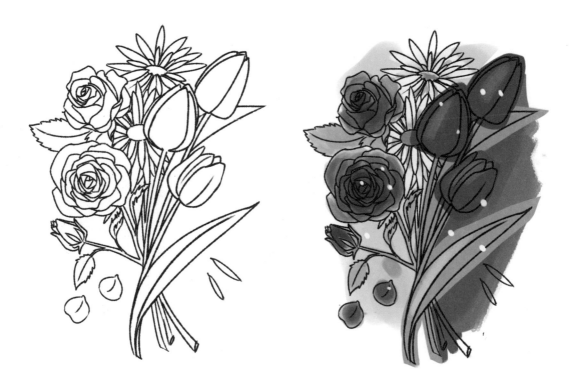

Artist Info: Images © Lea Hernandez. Website: www.divalea.deviantart.com

COUNTRYSIDE LANDSCAPE BY BRUCE LEWIS

Step 1

To draw open countryside, you can use the same basic principles as any one-point perspective drawing. First, establish an **eyeline/horizon**, then a **centreline**, then roughly sketch in the roads, trees and so forth that you want to depict. Experiment to get the balance you like.

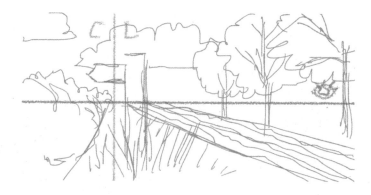

Step 2

Using a **lightbox** redraw your sketch more tightly. I've drawn a road with grassy verges, a hedgerow to the left and three trees to the right. I've added some copses of trees and some open fields. The focus of the picture will be the signpost and sign near the centreline.

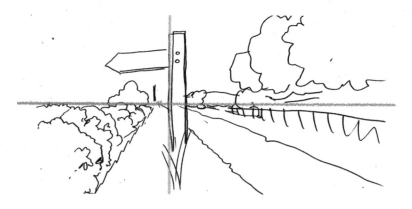

Step 3

Another lightbox drawing. I have cleaned up the sketch, adding in the verdure of the hedgerow (a lot of loopy outlines representing puffs of leaves) and the trunks and branches of the trees.

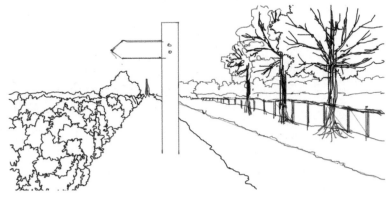

Step 4

This time, I want to go with a colour-based 'painted' approach, so this is where I lay down the basic colour. First, pick a **light source** – that is, the place from which the 'light' in your image will originate. In this case, I've placed the sun 'off camera' to the upper left.

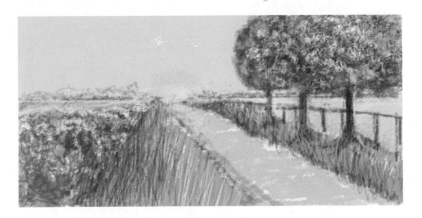

Quick Tip: If you don't have a lightbox, you can use a window pane and some sticky tape.

Step 5

Now, working on a separate sheet placed over the sketch, paint in flat areas of tone that will serve as the **base layer** of the trees, road, hedgerows, etc. Over this later add dibs and dabs of the same colour, which will multiply into (i.e. darken) the colour layer below.

Step 6

By adding **stippled daubs of colour** on top of the base colours, patterns of dark and light are created to suggest the presence of leaves. Finish out the trees and other leafy plants; grass should be painted in with quick, thin strokes of lighter and darker colour. Opaque **white accents** and erasures are then applied to suggest reflected light.

Step 7

Using the same **colour-over-colour** technique, I now draw in the signpost and sign, add in the foreground grass at the base of the post, then paint in shade and light areas. The shade is a wash (diluted shade) of light blue and grey painted over the colours (yellow sun = blue shadows). Add a few colour accents, some puffy clouds in a blue sky.

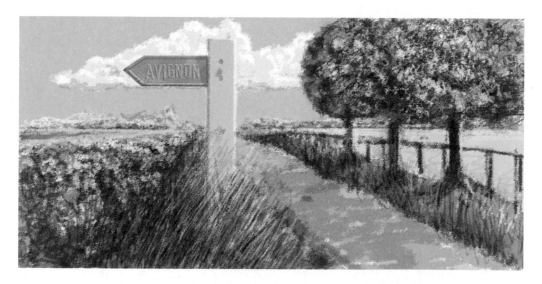

Quick Tip: I used software to draw this picture, but you could use watercolour, markers or coloured chalks/pencils – the technique is the same.

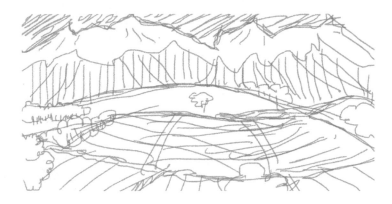

Step 8

Let's try a **line-based** approach. Here I've chosen an 'aerial' point-of-view (POV). Since the POV is above ground level, the horizon will be much further away than usual, so draw it in at whatever point you'd like, then sketch in the basic forms to fit.

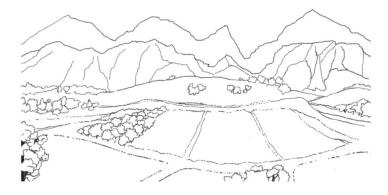

Step 9

Now use pencil or pen to begin adding in details: crop rows, trees, ridgelines of the various hills. Draw the lines In sketchily, freehand and don't be afraid to erase or use broken lines to keep things looking suitably organic looking. Use smaller lines for interior details, small objects and things in the distance.

Step 10

Now use your smallest lines to draw in the various details: contour lines, rock edges, leaves, distant trunks, etc. Small lines suggest waving grain; larger ones give the impression of shadowy mountain valleys. I've overworked this drawing a bit to show you the effects of various kinds of lines.

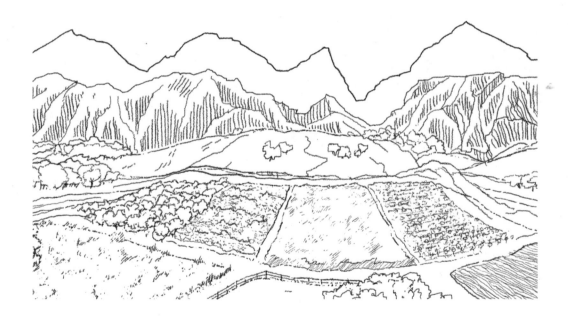

LOVERS IN A FOREST BY CHIE KUTSUWADA

Step 1

Make a rough planning drawing. One of the most important aspects when drawing a forest or woodland is to realize its depth. So think about at least three layers – the front area, the middle area and the deep background – when sketching.

Step 2

Make the more detailed rough drawing. This time, try to be as precise as possible. The front area, especially, should be drawn quite finely in order to create some three-dimensional effect. So, quite a detailed rough will be needed – drawing plants and leaves one by one without planning is a complicated job.

Step 3

Finish the line drawing of the front area and the middle area where the couple is standing. All is hand drawn. When you draw each plant and tree, it would be great to check some references to see the variations of the shape of the leaves and the other distinctive features.

Step 4

Add and finish the line drawing of the background. Use a thinner line to bring out the front and the couple. Also, the shapes of the trees can be simpler than those in the front and middle for the same reason.

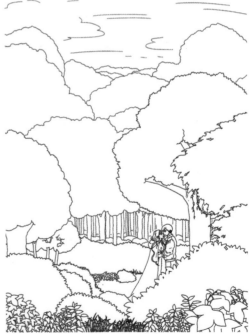

Step 5

Add the details to the leaves and the tree trunks. You do not need to add every single line and detail, but adding some indicating lines for veins and the textures of the trunks (please see the close-ups) will help the front area to stand out.

Step 6

Woods are very dark places so **shadows** are important to create atmosphere. Shape the shadows and paint or draw them in black. Towards the ground, there are more shadows and they are darker. Again, apply more complicated shading in front and simpler shading at the back.

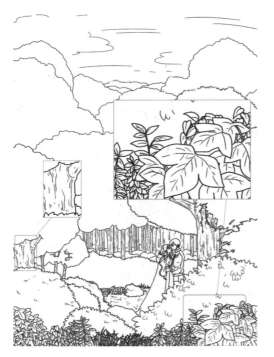

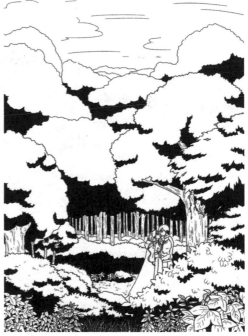

Step 7

If you would like to have a stylish and simple background, you do not need to do this stage of extra shading. But I quite like using hand-drawn lines for the extra shading on the next darkest area.

Step 8

This is optional. Just add a simple **gradation** of a fresh green colour and erase some parts to realize sunlight filtering through trees. It enhances the magical and romantic feeling of the woods.

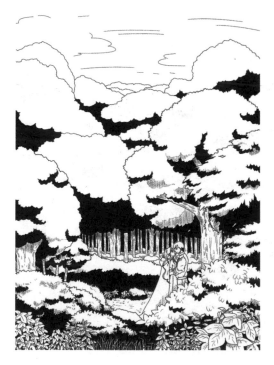

Artist Info: Images © Chie Kutsuwada. Website: www.chitan-garden.blogspot.com

SEASIDE BY BRUCE LEWIS

Step 1

To draw a realistic wave you need to know how waves work.

Waves happen when deep water flows rapidly onto a rising shore. As it rolls in, the amount of water remains the same, of course, but the rise of the land beneath it pushes it up higher and higher, forming a wave.

However, as the wave comes in, the water at the bottom slows down due to the friction created as it moves over the rising bottom. The water nearer the top continues to move at the same speed.

As you'll see on page 132, this speed lag creates a **rolling motion** (A) in the water; as the wave's bottom gets further behind, its top gets further ahead, until finally the top gets pulled down by gravity, disintegrating into droplets and foam (B). This is the crest of the wave. (Hokusai's *Great Wave, off Kanagawa*, illustrates this 'cresting' effect.)

So think of the wave as a cylinder of water, which reflects light in the same way any cylinder does. It is these cylinders of water that are key to drawing a seaside scene.

Step 2

Don't think of drawing the waves with lines; you're **building them up** in **thin layers** of colour. Using watercolour, pastel, markers or software, lay down the base layers of your scene. Being sketchy and loose is fine. Leave a few white areas where you want your wave crests to be.

Quick Tip: The best way to get a good 'watery' effect is to lay down colour in thin layers.

Step 3

Now start laying down blue on blue, creating horizontal bands of lighter and darker blue to create the cylindrical effect. Since you are looking into the open 'cylinders' of the waves, the bottom band of each will be lighter blue, with a

darker band over it (the shadow of the crest), then white (foam and spray) over that, followed again by base blue.

Step 4

Using white paint or its digital equivalent, add **crests** to the waves, using jiggly, freehand lines. First draw in areas of light blue using semi-transparent, diluted white, then add **pure opaque white** to give the crests a mottled, foamy look. The little strings of foam and bubbles created by the tide on the shore can be drawn in using thin, doodly lines of white.

Step 5

You already have an ochre base layer; now, lay on angled areas of yellow-brown to give the cliffs the wrinkled, folded look of weathered stone. You'll want to create a band of darker colour near the bottom to show the tideline. I've also added in the sky here.

Step 6

Gullies in seaside cliffs are often home to vegetation. I've darkened in the gullies here with a light blue wash to indicate shadow, then dabbed in some dark and light green to represent growth. I've washed out the cliffs with a couple of layers of thinned white to give them that sun-drenched look.

Quick Tip: Things further away in the picture should be proportionately smaller.

Step 7

Step 8

To add a starfish to the picture, I lay down a star-shaped patch of a suitable colour (top left), keeping in mind that a starfish is not flat, but three-dimensional. Once this is done, I create dimensionality by using patches of darker colour (top right). White accents and stipples give it that honest-to-starfish look.

... and that's it – the finished image is below. Please keep in mind that this is a very basic sketch; the seashore is a place of nearly infinite variety. I strongly recommend that you spend some quality time at the seaside if you haven't already. Get the feel of the sun, surf and sand.

Artist Info: Images © Bruce Lewis. Website: www.brucelewis.com

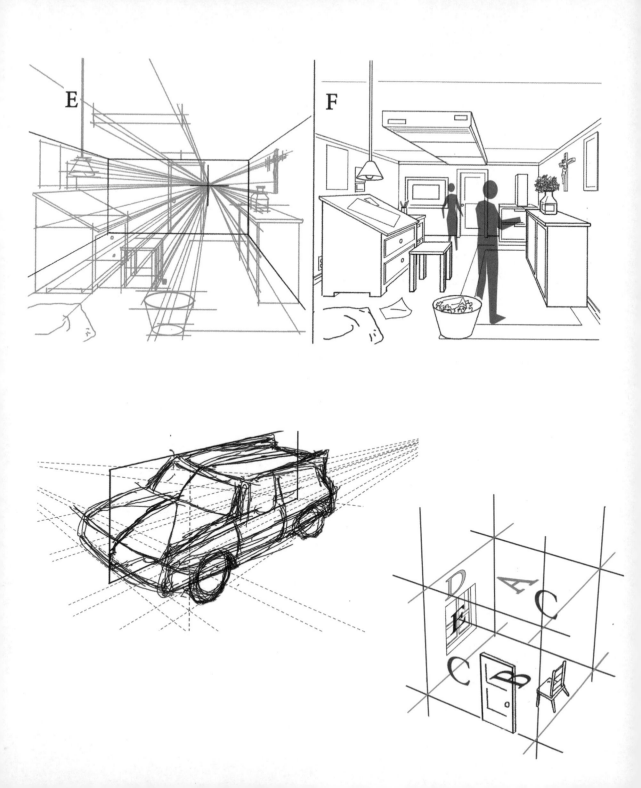

Perspective

PRINCIPLES OF PERSPECTIVE

The principles of perspective can be worked out with a ruler and pencil. This takes some practice and care, but before long you'll begin to notice the vanishing point in a picture or a landscape.

VANISHING POINTS BY NEWTON EWELL

Step 1

For the purposes of this text, we'll deal with the horizon as seen from the viewpoint of a person standing on the ground. This means that in your drawings you should place the **horizon** line at the **centre** of the page.

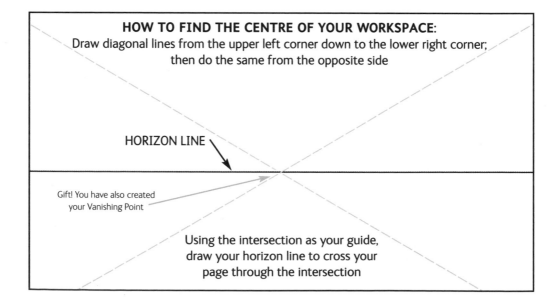

HOW TO FIND THE CENTRE OF YOUR WORKSPACE:
Draw diagonal lines from the upper left corner down to the lower right corner; then do the same from the opposite side

HORIZON LINE

Gift! You have also created your Vanishing Point

Using the intersection as your guide, draw your horizon line to cross your page through the intersection

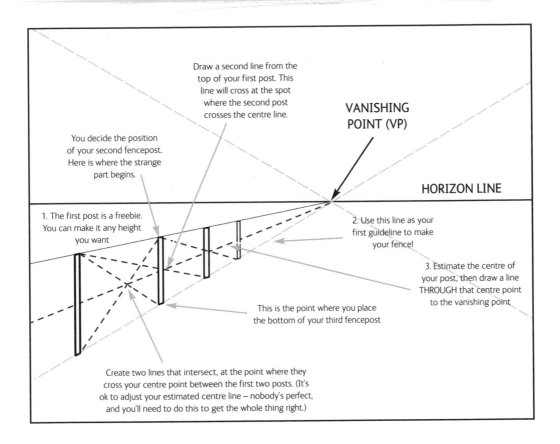

Draw a second line from the top of your first post. This line will cross at the spot where the second post crosses the centre line.

VANISHING POINT (VP)

You decide the position of your second fencepost. Here is where the strange part begins.

HORIZON LINE

1. The first post is a freebie. You can make it any height you want

2. Use this line as your first guideline to make your fence!

3. Estimate the centre of your post, then draw a line THROUGH that centre point to the vanishing point

This is the point where you place the bottom of your third fencepost

Create two lines that intersect, at the point where they cross your centre point between the first two posts. (It's ok to adjust your estimated centre line – nobody's perfect, and you'll need to do this to get the whole thing right.)

Step 2

First, let's make something easy – a fence that goes off into the distance towards the horizon. First, I drew a fence post. You can draw yours any size you like but I went with the little stumpy one. Then I drew a line from my **vanishing point** (VP) to the edge of my paper, making sure that the line touches the top of my first fence post. I now have the two guidelines I need to make this post look good.

Quick Tip: You can place vanishing points anywhere on your page – they do not have to be on a central horizon; and you can make as many vanishing points as you would like.

Step 3

If you draw two diagonal lines from the top to bottom corners, the horizon line is determined to be where the two lines cross. Let's do the same thing with our fence posts.

I draw another fence post, at a distance from the first post that looks good. Next, I draw two diagonal lines between the fence posts, top and bottom. These crossed lines give me a centre point, through which I draw

a third horizontal line from my vanishing point, making sure that it goes through my centre point.

You now have all you need to draw all the remaining fence posts in perspective. Let's draw another diagonal. This one starts at the top of Post 1, and runs through the centre point of Post 2, and ends touching your base line. Congratulations – you have just found the base of Post 3!

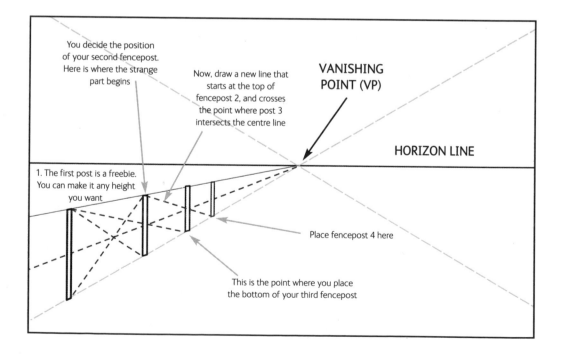

You decide the position of your second fencepost. Here is where the strange part begins

Now, draw a new line that starts at the top of fencepost 2, and crosses the point where post 3 intersects the centre line

VANISHING POINT (VP)

HORIZON LINE

1. The first post is a freebie. You can make it any height you want

Place fencepost 4 here

This is the point where you place the bottom of your third fencepost

From here it gets easier. To find the base of Post 4, draw a diagonal from the top of Post 2 through the spot where Post 3 crosses your centre line. Your fence posts are imitating real life – they appear to get closer together the further away they are from your point-of-view.

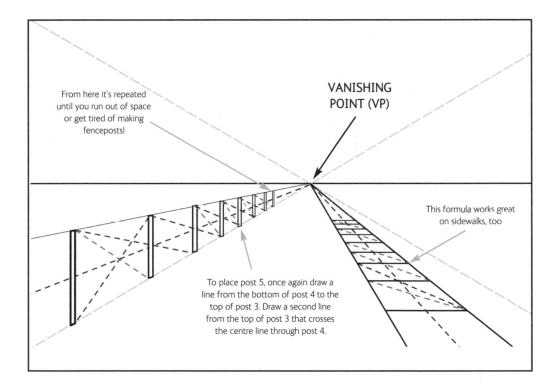

From here it's repeated until you run out of space or get tired of making fenceposts!

VANISHING POINT (VP)

This formula works great on sidewalks, too

To place post 5, once again draw a line from the bottom of post 4 to the top of post 3. Draw a second line from the top of post 3 that crosses the centre line through post 4.

Step 4

These are the basics. From here, this formula lets you draw all sorts of things: railway tracks, sidewalks, even mighty rivers can be drawn with this formula.

Now I can hear you saying, 'That's nice, if all I want to do is draw fences and sidewalks. Where's the cool stuff?'

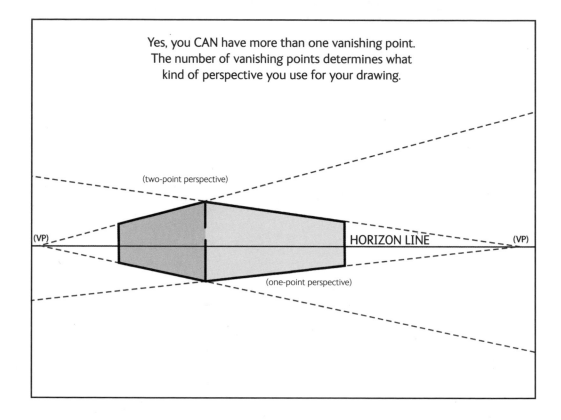

Yes, you CAN have more than one vanishing point.
The number of vanishing points determines what
kind of perspective you use for your drawing.

(two-point perspective)

(VP)

HORIZON LINE

(VP)

(one-point perspective)

Step 5

Two-point (or angular) **perspective** allows you to create objects using two vanishing points. This makes your object (in this case, a box) look more realistic.

You can place vanishing points anywhere you want along the horizon. Here,

I put both VPs directly on the horizon, near the edges of the paper. Placing the VPs closer together will bring the near corner closer to your point-of-view; further apart, and the nearest corner is further away.

Step 6

This is an example of **three-point perspective**. We've moved our VPs into the upper corners of our paper, and added a third VP at the bottom-centre of our page.

This creates a perspective view that indicates looking at the top of a tall building from a very great height.

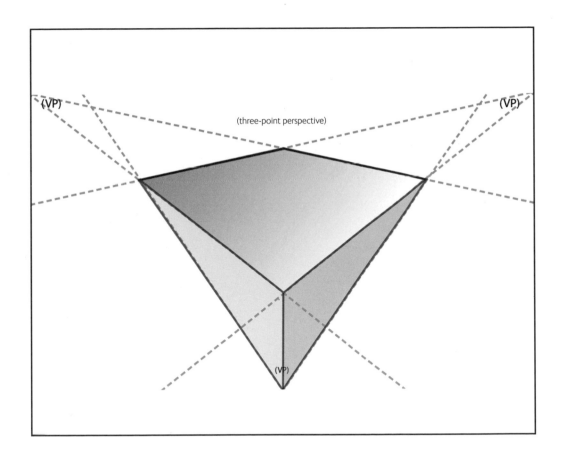

(VP)

(VP)

(three-point perspective)

(VP)

Artist Info: Images © Newton Ewell. Website: www.newtonewell.com

FINDING THE HORIZON BY NEWTON EWELL

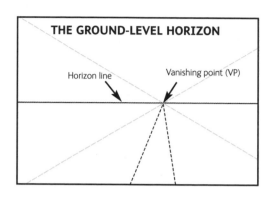

THE GROUND-LEVEL HORIZON

Horizon line

Vanishing point (VP)

Step 1

The horizon is the imaginary line between the air above and the ground below. If you're drawing a point-of-view (POV) of a person standing on the ground, the horizon line will pretty much always be at or near the centre of your paper.

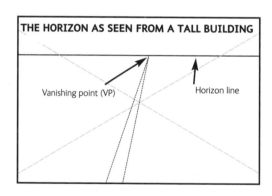

THE HORIZON AS SEEN FROM A TALL BUILDING

Vanishing point (VP)

Horizon line

Step 2

At the top of a high building things start to change. What you perceive as the horizon appears to move upwards along with you. Meanwhile, the view has changed – what looks one way at ground level now appears differently.

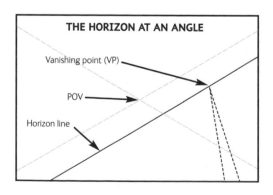

THE HORIZON AT AN ANGLE

Vanishing point (VP)

POV

Horizon line

Step 3

This is where we take off the training wheels and start to deal almost solely with objects in space. Here, it appears that we're suddenly in the air banking hard to the right! Just a trick of the eye; I simply angled our horizon line to the right side of your POV.

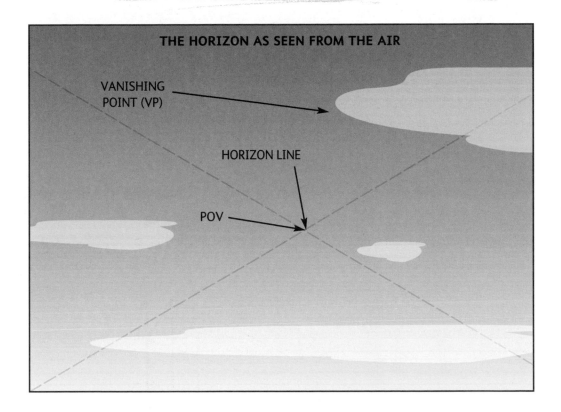

Step 4

Here's another view from a high place. Not everything from your POV is in one-point perspective; everything you see does not radiate from one vanishing point (that would be frightening!). Instead, things appear to have their own vanishing points, resulting in what's called a *panorama* (a view of everything in sight). This happens because our minds take in everything and then gauges where all the vanishing points are relative to your position.

Quick Tip: You can set your horizon line anywhere on your page you'd like. Reality is by invitation only when you're drawing.

Step 5

To simulate what your mind creates, let's look at two-point perspective. Here we see two buildings in two different positions from the same point-of-view. Because the buildings are so tall, and are in different positions, there are two vanishing points.

To achieve this effect, we just place two vanishing points on the horizon line. This way, everything fits our point-of-view and looks right.

The red box in the centre of the drawing isn't a third building – it's there to highlight where the two vanishing points intersect at ground level in the POV.

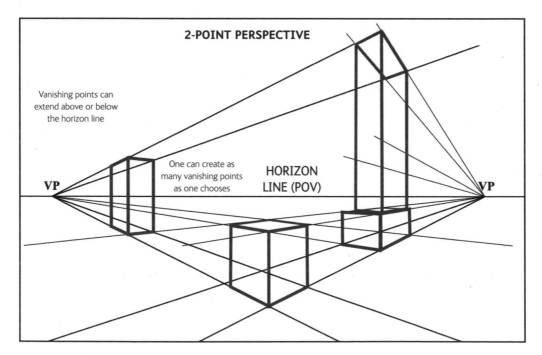

Quick Tip: From your POV, vanishing points can come from anywhere in your field of vision. You can have as many points of perspective in your art as there can be in reality.

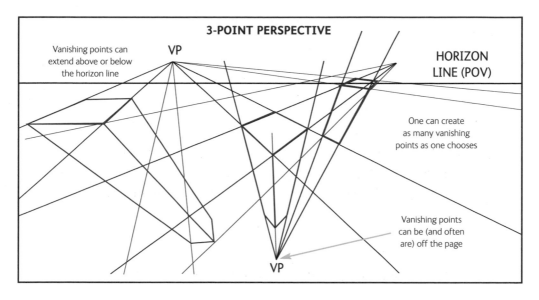

3-POINT PERSPECTIVE

VP

HORIZON
LINE (POV)

Vanishing points can
extend above or below
the horizon line

One can create
as many vanishing
points as one chooses

Vanishing points
can be (and often
are) off the page

VP

Step 6

The drawing below, while still in two-point perspective, has six different vanishing points. All
are valid, because they conform to our artificial horizon line. The lower three objects are in
three-point perspective. The upper object is in two-point perspective. This makes the top box
appear to be flying, which we'll use in our spaceport (*see pages 160–62*).

The image above zooms in on just
the 3-point perspective objects to
give you a better look. This kind of
view is perfect for creating
cityscapes in your artwork.

VP

**2-POINT
PERSPECTIVE**

Vanishing points can extend
above or below the horizon line

VP

VP

HORIZON LINE (POV)

**3-POINT
PERSPECTIVE**

VP

One can create
as many vanishing
points as one chooses

Artist Info: Images © Newton
Ewell. Website: www.newtonewell.com

DRAWING A BUILDING IN PERSPECTIVE
BY NEWTON EWELL

Step 1

We will use projects we completed in the beginning as bases for some of the more advanced projects. The principles work equally with pencil and paper or the drawing software of your choice.

Toolsyou will need are: tracing paper; eraser; straightedge: a ruler or triangle (any old straightedge will do; a fairly hard (No. 2, HB or 2H–4H) pencil.

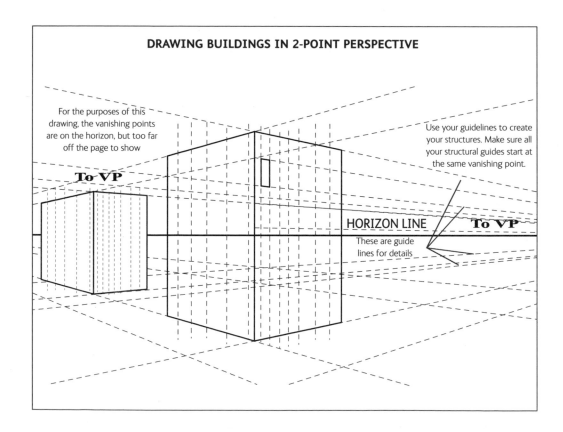

DRAWING BUILDINGS IN 2-POINT PERSPECTIVE

For the purposes of this drawing, the vanishing points are on the horizon, but too far off the page to show

To VP

Use your guidelines to create your structures. Make sure all your structural guides start at the same vanishing point.

HORIZON LINE

To VP

These are guide lines for details

Step 2

Guidelines are dashed in red. To draw any building in two-point perspective, just follow the rules on the Step 1 and 2 images.

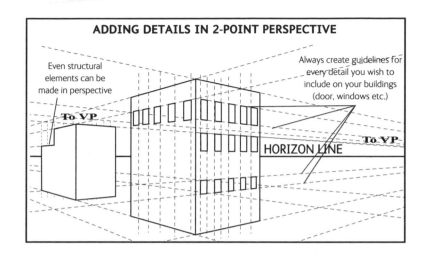

ADDING DETAILS IN 2-POINT PERSPECTIVE

Even structural elements can be made in perspective

Always create guidelines for every detail you wish to include on your buildings (door, windows etc.)

To VP

To VP

HORIZON LINE

Step 3

This shows me applying the same rules to curved shapes. There's some very funky architecture out there and you need to be able to render domes and curves in perspective to enjoy drawing it.

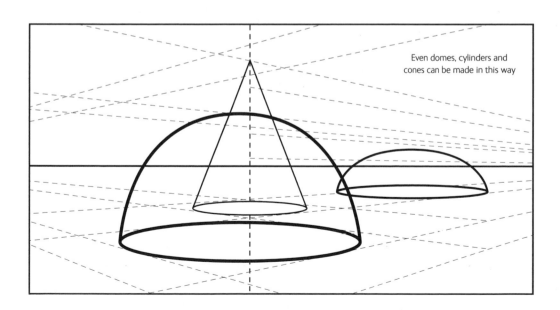

Even domes, cylinders and cones can be made in this way

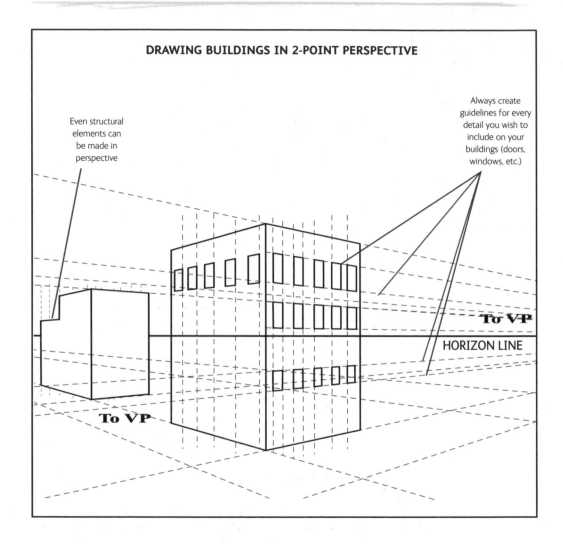

DRAWING BUILDINGS IN 2-POINT PERSPECTIVE

Even structural elements can be made in perspective

Always create guidelines for every detail you wish to include on your buildings (doors, windows, etc.)

To VP

HORIZON LINE

To VP

Step 4

If you have flights of fancy of your own, you can execute them in two-point perspective.

If you need to make really complex shapes, go back to the previous tutorial and take a look at the multiple-perspective drawings.

Step 5

Three-point perspective is not difficult to handle as long as you rule your guidelines carefully. Remember that elements of a building can have their own perspective.

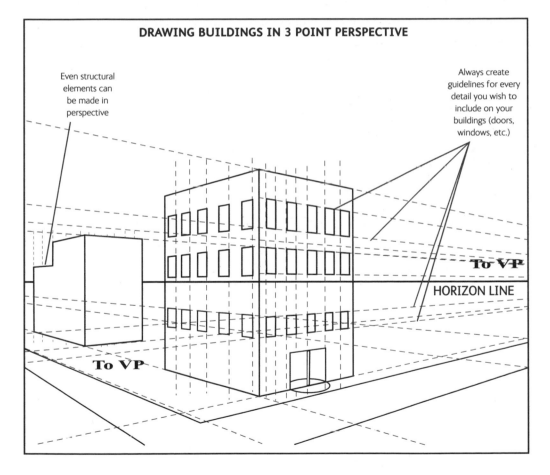

DRAWING BUILDINGS IN 3 POINT PERSPECTIVE

Even structural elements can be made in perspective

Always create guidelines for every detail you wish to include on your buildings (doors, windows, etc.)

To VP

HORIZON LINE

To VP

Artist Info: Images © Newton Ewell. Website: www.newtonewell.com

APPLYING PERSPECTIVE TO SETTINGS

Using the principles you've just learned, make a drawing in perspective. With practice, you can apply these techniques to anything you see around you, from a table laid for a meal to a football stadium.

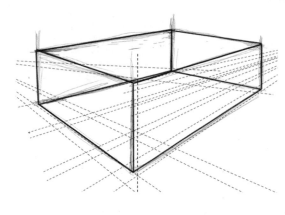

DRAWING A CAR
BY NEWTON EWELL

Step 1

We'll make use of our two-point perspective grid as a guide for drawing. If you do not have your two-point perspective grid, that's fine – you can make one based on the red dashed lines in Step 1. Sketch a box as seen here. This is called a bounding box, and provides the outer limits of our car's size.

Step 2

Once our box is done, let's cut it in half along the long axis of the box, as seen here.

Step 3

Sketch a side view of your car, and use your perspective lines to make sure its outline looks good. Use your perspective lines to first lightly sketch an image of the car's side view onto the far side, and then the near side of our bounding box. The car's outline has to fit within the boundaries of the far wall.

Step 4

When those side views are complete, we begin to see that our perspective guides show how we will begin joining the near, far and middle side views we've laid out. Use broad, light strokes to make these lines.

Step 5

Your lines won't be perfect the first time; you can see the broad strokes I use in this drawing. Just make sure that the shape of the vehicle conforms to your bounding box.

Step 6

Once your overall shape is finished, go ahead and add details.

Quick Tip: Use photographs of cars you like as a guide; the more visual information you have, the better your details will be.

Step 7

After that, tighten your illustration using circle templates and curves. Take your time with this process, because this is your final drawing. It's the little things that make the car look realistic: headlights, windows, tyres, a grill – all these will help bring your imagined machine to life.

Step 8

Now you can add some special effects to make your vehicle stand out. Again, make use of photo-references to place your overall shading. Photographs will also help you with finishing touches, such as light and shade.

Artist Info: Images © Newton Ewell. Website: www.newtonewell.com

DRAWING A ROOM BY BRUCE LEWIS

Step 1

A room is a box. It has a top (A: the ceiling), bottom (B: the floor), and sides (C: the walls). The first step to drawing a room in **perspective** is to put yourself into that box, sitting in a tiny chair, looking at the side of the box opposite you (D) through a window (E) that is just a hole cut in the cardboard.

Step 2

In front of you, you can see things that are about 60 degrees above your eyeline, and about 75 degrees below it. This is the visual field. Within your visual field lies most of the 'ceiling' (A) and 'floor' (B) of the box, two 'side walls' (C), and the 'wall' opposite you (D). Through the 'window' (E) you can see the horizon.

$$\theta = 135°$$

Step 3

The **horizon** (green line) has another name: the **eyeline**. Sitting or standing, the horizon will always appear to be at eye level as long as your head is held level. The blue line is the centreline of your vision, the imaginary plane that divides your left side from your right side.

The room: the far wall (D) appears to be much smaller than you'd expect, and where the ceiling (A) and the floor (B) meet the side walls (C), four lines are formed, representing the top and bottom edges of the room. Now look through the window (E). When you use your imagination to extend these lines beyond the far wall, you will notice that they meet on the horizon at exactly the same point: the point where your eyeline and centreline cross. This point is the **Vanishing Point** (VP), the point on the horizon where things become too small to see. The VP is the key to drawing a room in perspective.

Step 4

Let's draw a room in perspective. Sketch in the far wall: a rectangle. Imagine it's the size of a typical indoor wall, about 2.4 m (8 ft) high. Assume you are standing; that puts your eyeline/horizon at about 1.7 m (5 ft 5 in) from the bottom of the wall, so draw in a horizontal line (green) about ²/₃ of the way 'up' the wall. Your **centreline** (blue) should bisect this vertically. VP established!

Step 5

Starting at the VP, sketch in four edge lines, one to each corner of the wall and on beyond. Once you have the lines roughed in, go to the lightbox and neatly trace the edge lines on a new sheet of paper using a straightedge to keep things tidy.

Step 6

Now use the lightbox to redraw the four sides of your wall and erase your construction lines. Be sure to mark the VP with a plus sign; you'll need it.

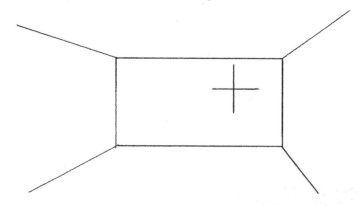

Quick Tip: In one-point perspective, all lines going 'away from' the point-of-view of the observer (you) converge at the VP; and the further away an object is, the smaller it appears.

Step 7

Furniture is mostly rectangular. Assuming this furniture is lined up with the walls, sketching it all in is easy: just rough in the furniture (E), then extend construction lines from the edges of each item to the VP as shown. Remember, only lines going *away from* the observer and *towards* the VP converge; side-to-side and up-and-down lines are strictly horizontal and vertical respectively.

Note that things at an angle (e.g., the drawing board) and non-rectangular objects (e.g., the lamp) are distorted by perspective. You'll sort of have to feel your way through this. Note also that the further 'away' from the observer each item of furniture or part thereof is, the smaller it looks. Finally, once you have all the stuff roughed in, redraw it (F) on the lightbox, omitting construction lines and erasing things that would not be visible from this point-of-view. (I have added in the human figures for scale.)

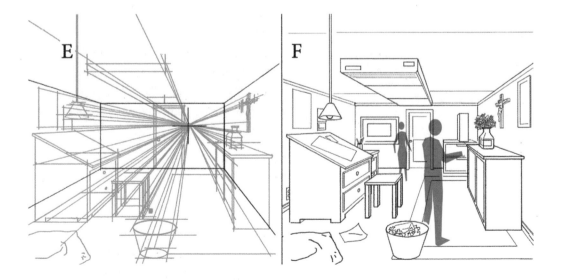

Artist Info: Images © Bruce Lewis. Website: www.brucelewis.com

DRAWING A SPACEPORT BY NEWTON EWELL

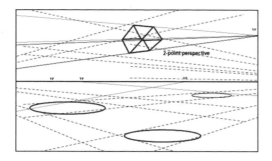

Step 1

Our first step is creating our grid. We will use a flying box in **two-point perspective** to place where we want our spaceship. Once we do that, we will place our pads where we want our buildings to be.

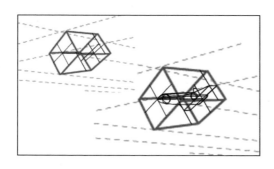

Step 2

Next, let's sketch out what we want and where, using our lines and pads as a guide. We'll focus first on our little spaceship. Just like designing a car, we sketch in our **bounding box**. Our base lines to keep our shuttle in perspective are laid out.

Step 3

Next, let's lay out the positions of our spaceport buildings. I created three artificial islands, all set out on our alien ocean. Just sketch everything in lightly; you don't have to commit to drawing everything on this pass.

Step 4

Here we have everything drawn in, except for our outbound spaceship. Let's take a closer look at how we do that.

Step 5

I created a larger version of our spaceship bounding box from before. Using the guidelines I already had in place, it's easy work to finish our space shuttle.

Step 6

A few details, like vents and hull plates, give our ship a feeling of mass. They also call attention to the ship as it travels across the sky.

Step 7

This image shows us everything – all placed as it should be. Now, if you have been following, don't feel bad if yours isn't exactly like what I've put down. Please feel free to create your own style and sizes of buildings; it's your picture, after all!

Step 8

Now, let's add some finishing touches. In the rough sketch, you can see I placed our buildings on platforms set out in the water. We'll first make some waves, then place shadows on the rocks and buildings. Add the jet trail of our shuttle's launch, and finish up with a couple of moons in the sky.

FIGURES IN PERSPECTIVE ON A STREET
BY KAT LAURANGE

Step 1

Start with a grid, a sort of a rough-and-tumble version of the carefully ruled perspective lines you may have learned.

Place your figures on the grid. Note the line from the head of the foreground figure to the back, indicating their relative size.

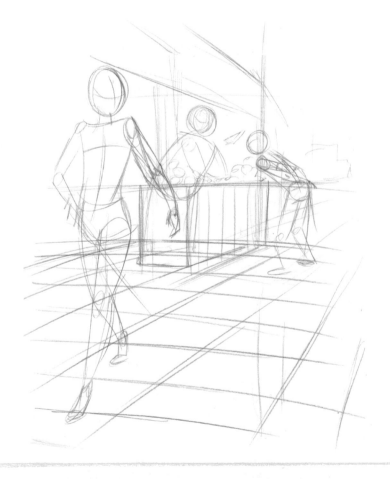

Step 2

Start refining the figures, based on the initial sketch, building up from basic shapes and fixing any problems; for example, I changed the foot position on the foreground figure. I'm picturing a street market sort of scene, so I've also roughed in a market stand and seller.

Step 3

Continuing refining, adding clothing and such details. Remember to draw through where figures overlap – don't rely on guesswork. Extra construction lines can always be removed later.

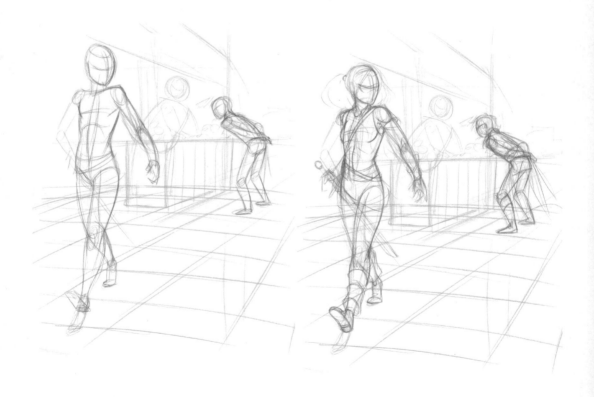

Step 4

Finish the figures; I like to save hands and faces for last, to make sure everything else is first placed correctly.

Step 5

Time for the background! The market stalls are basically just boxes in perspective; use the grid lines to place them. It's all right for the perspective to be imperfect. Nothing in the real world is perfectly straight, not even manmade streets and buildings.

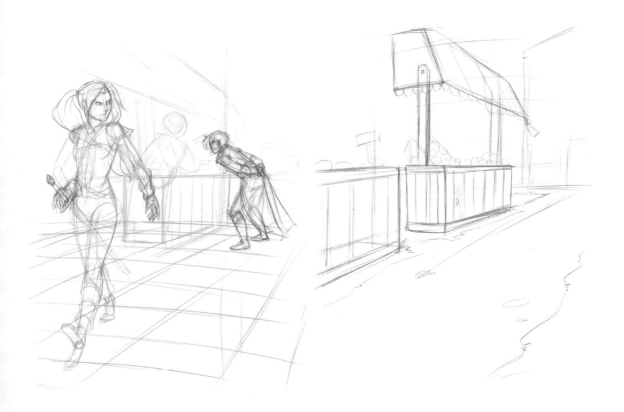

Step 6

I added the market seller's details. Since he's in the background, he doesn't have to be as refined as the main figures, but I still wanted him to have a bit of character.

Step 7

All that remains is to pull everything together. It's fine if your 'final' pencil lines are rather loose; it can lend a charming roughness and energy to the drawing that more polished pencils might lack.

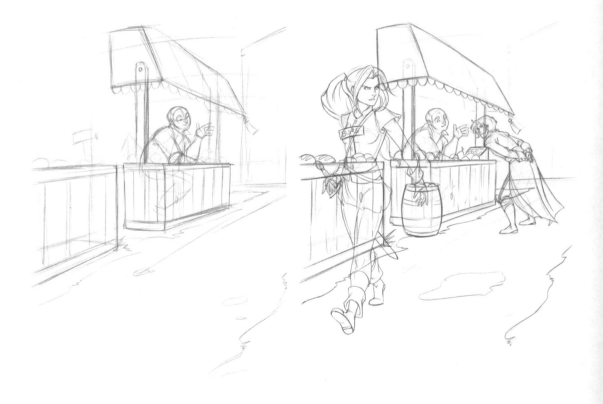

Step 8

I shifted the main figures slightly in the final drawing to avoid tangents with background elements and to improve the composition. I also lightly added some further background elements to give the illusion of depth.

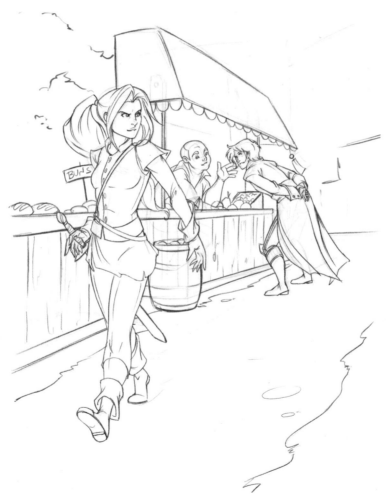

Artist Info: Images © Kat Laurange. Website: www.facebook.com/KatLaurangeArt

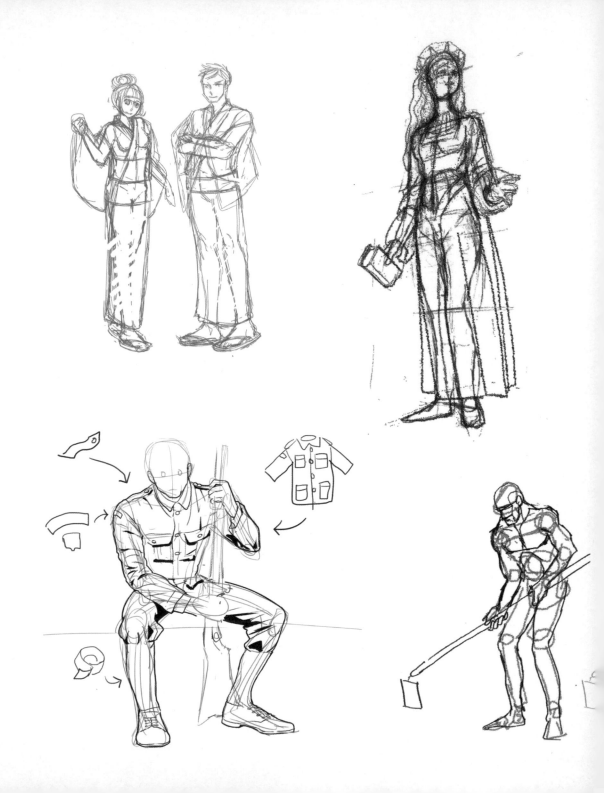

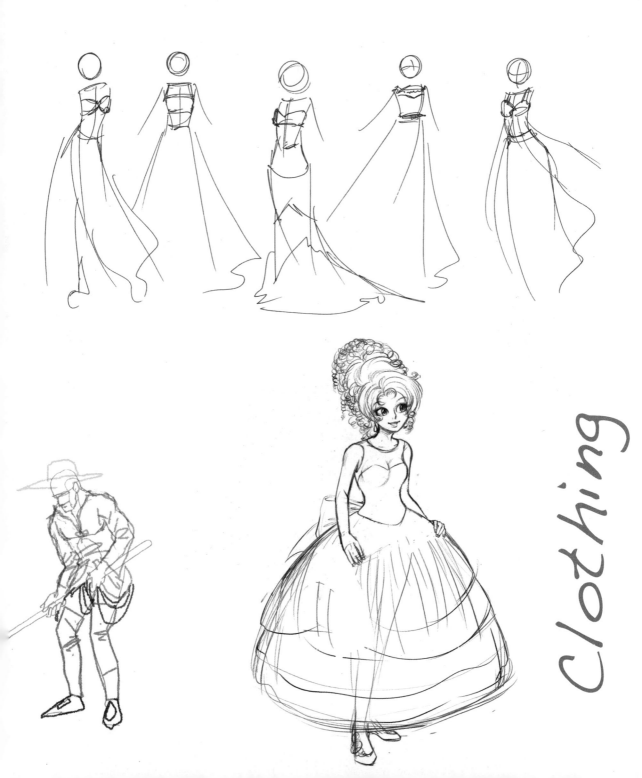

Clothing

CONCEALING AND REVEALING

Clothing can either conceal the
body or reveal it, and the play
between the two is a fascinating
area for the artist.

GLAMOUR AND FANTASY
BY TONY LUKE

One of the great unspoken 'rules of art' is that there aren't any. Yes, there are rules of perspective, human anatomy and so on, but it's *your* story, so tell it the way *you* want to, by any means necessary!

The glorious thing about today's digital age is that there are an almost infinite number of apps and techniques available to those who, while very creative and driven, may not be confident working in 'traditional' art skills. My own workflow mixes 3D alongside Photoshop, a fun and flexible combination that has very much taken hold in the digital artist community over the last 20 years. The 3D assets you generate can also be used in other media, such as animation or games.

There are many 3D apps out there of varying degrees of complexity and user-friendliness; for this section we'll deal with simple Character generation, and for this task Poser is the main go-to app for many artists. Check it out at www.my.smithmicro.com/poser-3d-animation-software.html.

I've used Poser in most of my work for over 15 years now, and have found it to be fun, intuitive and capable of stunning results, especially when matched with Photoshop – check out the work of 'Spawn' and 'Witchblade' artist Brian Haberlin (www.digitalarttutorials.com) as proof (he also sells very useful video tutorials).

Quick Tip: If you're not familiar with the Poser and Photoshop apps, total beginners can get going using the Daz Studio app at www.daz3d.com/get_studio – it's free!

Step 1

StartUp: Here, I've selected the Aiko character by Daz3D, and opened it up in Poser. Aiko is a 'template figure', one that you can tweak to your heart's content, and comes with a huge variety of settings for body type, facial features, etc. These can be adjusted using the Parameters dials in Poser.

Step 2

Here's 'Basic Aiko' up close ... and in dire need of accessorizing! While you decide what hairdo to give her, play around with her parameters adjustment options; they're what tweaks a figure's body and facial features and turn a template into something that's uniquely yours.

Step 3

Poser has various 'rooms' in which you can choose from a variety of hairstyles, clothing, material options and so on. Here, I've selected a third-party hairstyle – preloaded into my Poser library – and applied it to the Aiko figure. Some figures demand that you 'conform' additional bits and pieces to the 'main' figure – don't forget to do this if required, or your props and clothes won't 'move' with the main figure when you come to select an action pose for her later on.

Step 4

Aiko is starting to look more human. At this point you'll be able to select different styles of eyeball and eye colour, and even skin and make-up options.

Quick Tip: Although Poser has a decent Undo feature, it's simpler to keep a folder of the project files saved at various stages of development – you never know when you might need to go back to a particular point to make adjustments.

Step 5

Aiko comes with a default bikini. We aren't going to use it. Select a Skin from the library; this 'nudifies' the figure ready for new clothing.

Step 6

I'm trying out a few Clothing options on the figure until deciding on something simple ... a swimsuit. Clothing is usually loaded as a 'separate figure', one that you conform and adjust to the main figure using the **parameter dials**. You'll most likely need to fiddle around with the dials to get a good 'fit', but it's time well spent.

Quick Tip: How you dress your figure is somewhat dependent on what's in your Poser library; luckily there are a lot of good freebies out there on the internet for beginners.

Step 7

In the Materials room, I've given the swimsuit a hot pink style, and applied a pre-set pose to the main figure. You can, of course, twist and bend your character manually using the various tools on offer, but it's usually easiest to load a pose that's close to what you're after and make alterations from there.

Step 8

Every Poser figure uses **Skin templates** for the Head and Body which can be opened up in Photoshop and worked on; here, I've

airbrushed in some soft black around the eyes to give her face a little more 'mystery'. Save out the result and, back in Poser, reload the new skin using the tools in the Materials room.

Quick Tip: There's no limit to what you can add to a skin template at this point – crazy make-up, wild tattoos ... it's up to you.

out the scene several times using the different settings, as this gives extra flexibility when taking the project into Photoshop (think: layering different styles on top of each other, and playing around with the Layer Styles for some interesting results).

Step 9

The most recent version of Poser comes with a variety of ways to render out an image, from full-on 3D to adjustable black-and-white line art, as seen here. Usually, at this stage I render

Step 10

Armed with whichever style render you've decided upon, head into Photoshop and paint, layer and tweak to your desired result. And ... done! Well, at least until you decide to go back and change the hair colour, or the eye shape, or ... you get the idea.

Quick Tip: The black and white option here is especially handy if you work in **Manga Studio** instead of Photoshop

Tiffin

Here's a few experiments of my own to encourage you to play with the techniques and tools in Poser. Tiffin was created in Poser using the techniques outlined above.

Yuki-Onna

My variation on the legendary Japanese 'Snow Queen', with very contemporary digital effects.

Hibiki

The same high-shine effects used for Yuki-Onna create a very different mood here.

Rokurobi

Another character from Japanese folklore – here I've used different effects to suggest an old photograph while keeping a contemporary edge.

Artist Info: Images © Tony Luke. Website: www.tonyluke.deviantart.com

MEDIEVAL COSTUME BY BRUCE LEWIS

Step 1

From ancient times until the fourteenth century, Western and Mediterranean people basically wore the same sort of clothing: a linen shirt (A), sometimes short linen 'breeks' (trousers, B) and hose/leggings (C); leather shoes, boots, or sandals (D); and some sort of hat (E) or scarf, with a robe, or surcoat (G). Add a girdle/sash/belt (H) and sometimes a cap or skullcap (F) for the shaven scalp. In cold wet weather, a longer tunic (J) and tall boots (K) were worn with a moisture-resistant cloak (L), mantle and hood (M) along with an ornamental brooch or clasp (N). Kings and cardinals wore the same in fancier materials; ladies wore the same, but usually cut longer.

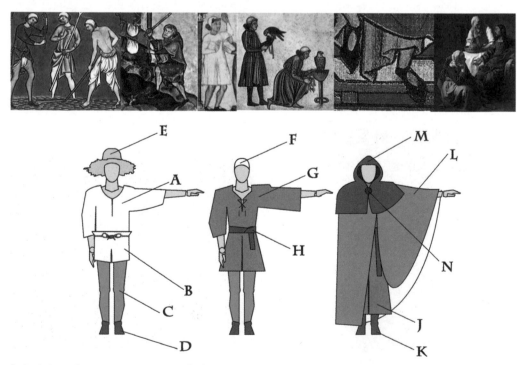

Basic clothing of western man antiquiyu - C.A.D. 1500 *(Female similr)*

Step 2

We're going to start at the bottom of medieval society: John Peasant, tilling the soil c. 1300. I sketched him in the standard back-breaking agricultural labour pose, then added a shirt (stuck to body by perspiration), followed by the tunic (blue), breeks (orange), leggings (green), shoes (red), and hat (yellow).

Step 3

Now I flip the drawing and add in a loose, **sketchy pencil**, followed by the colour treatment. By dressing in layers, people who spend most of their days outdoors can easily adapt to changing weather.

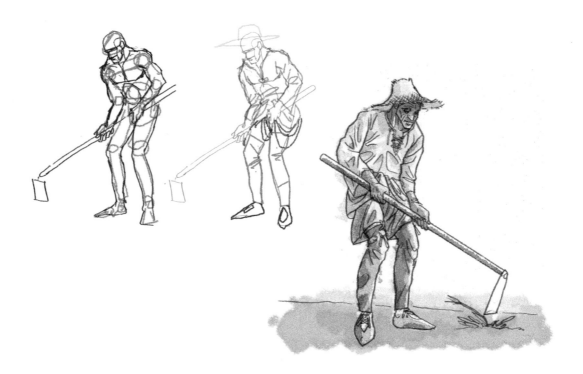

Quick Tip: Notice how baggy the breeks are, with the rolled waistband and the leather thongs tying the leggings to them.

Step 4

Now we'll look at a queen. You'll notice that she's wearing a lace collar (A) over a linen shirt (B), a laced-up corset or kirtle (not visible, C) topped with an (expensive, silk, hand-embroidered, gold-trimmed) surcoat (D) over that. The mink cuffs (E) add a touch of regal luxury.

Step 5

Now let's sketch a medieval queen based upon Queen Isabella. Start with a basic **seven-head figure**. Make her nice and curvy. Notice the reference lines I drew in at the feet, knees, waist and eyeline to help me get the perspective right. Notice, too, that her left leg is bent, as she places her weight onto her right leg.

Step 6

Now I lightbox the sketch and draw in the clothing, then splash on some colour. Notice the texture of the gown: royal types were among the few that could afford costly silk garments. Also notice how her raised leg ties in to the continuous contour of her body, with '**shines**' painted in to show light reflecting off her draped form.

Step 7

Just because this is a quick off-the-cuff sketch, it doesn't mean you have to skimp on the details. She's wearing a lace and linen chemise, a kirtle (the gold dress) in place of a tunic, and a long surcoat (the gown). Notice, too, that I managed to get in her veil and crown.

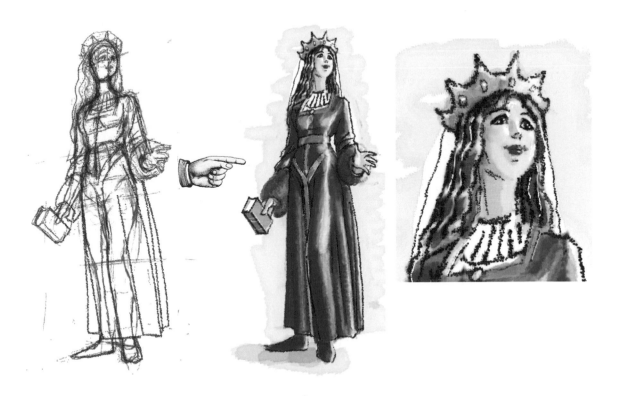

Step 8

Everything most people 'know' about the European Middle Ages is wrong. They kept as clean as they could. They had hems on their garments and produced clothes with intricate embroidery and other sophisticated detailing. And they were not all knights and queens; most people were simple farmers, herdsmen, or (in the later years) merchants and tradesmen.

When you draw figures in medieval costume, try drawing realistic figures wearing realistic clothing rather than something a character in a fantasy role-playing game might wear. I think you'll find it's just as much fun.

Artist Info: Images © Bruce Lewis. Website: www.brucelewis.com

DRAWING A KIMONO
BY CHIE KUTSUWADA

Step 1

Make a rough planning drawing. In order to avoid the character looking like a head and shoulders with a kimono hanging flat from them, I recommend you draw a nude figure first then dress it. This helps you keep the shape of the body under the clothing.

Step 2

Dress the figure. The first thing to remember is that most kimono material is firm and thick and not elastic, and also its cut is very straight-lined. A kimono will never be skin-tight or figure revealing.

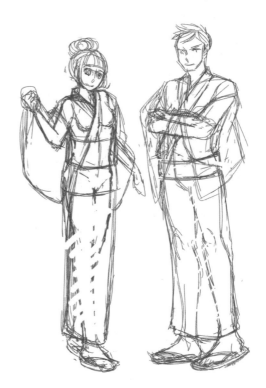

Quick Tip: Some kimono styles, such as long trailing sleeves, are only worn by young females, others only by men. For traditional clothing, do your research before you start, in order to avoid mistakes.

Step 3

Add more details of your kimono before inking. At this stage please look at the close-up of the necklines, inset. All Japanese kimono should be wrapped with the left hand side over the right. Ladies' kimono should be worn with a bigger space between neck and collar than men's kimono.

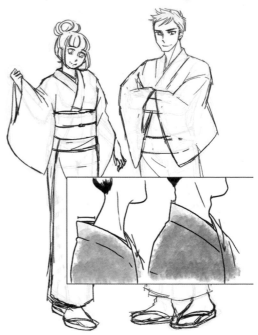

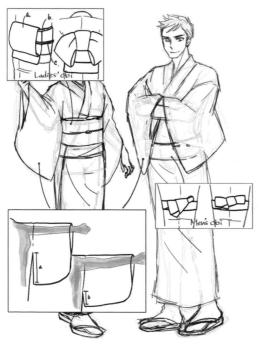

Step 4

Men's obi (belts) are narrower and worn much lower than ladies'. Ladies' obi are worn with two other sash belts. Look closely at the examples of the knots. Also pay attention to the shape of the sleeves. They are like a sack. Points a and b are not sewn together. The kimono shoulder line is slightly dropped, rather than sitting exactly on the shoulder.

Quick Tip: All Japanese kimono should be wrapped left over right. The opposite way – right over left – is only used when dressing dead people for their funerals.

Step 5

Inking. As I mentioned earlier, the kimono material is firm and/or thick, so no soft or curvy lines should be used. Also, because of the nature of its material, there should not be too many little creases. In wearing a kimono, one must aim for a straight, uncluttered effect.

Step 6

Traditionally, ladies' kimono are more colourful with more varied patterns. Many patterns and colours have symbolic meanings, associating with seasons and lucky charms. There are many variations on a kimono – I advise you to do some research.

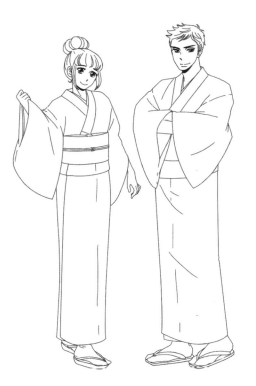

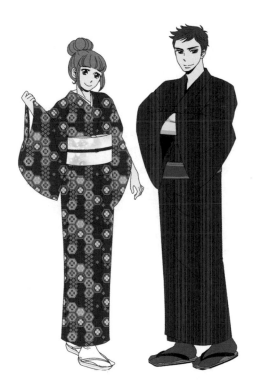

Artist Info: Images © Chie Kutsuwada. Website: www.chitan-garden.blogspot.com

WORK AND PLAY

Modern clothing follows the same basic shapes for men and women. Workwear is as much a uniform as military dress. But when we dress up for a night out or a special occasion we can let ourselves indulge – and you can dress your drawings in any style you choose.

Step 1

If you're designing a battledress for an imaginary regiment you can ignore utility, but if you know a bit about an actual one, it sure gives great ideas for future costume design. For example, we can pick an iconic 'khaki' uniform to draw: a British infantry soldier waiting for action in the First World War.

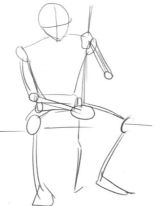

BATTLEDRESS: BRITISH INFANTRY, 1914
BY INKO

Step 2

Now you see he is leaning slightly on one arm. The first two steps for the drawing are the same as for someone in normal clothing – how hard can it be?

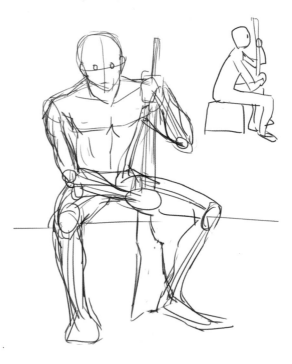

Step 3

Like magic, the figure suddenly has the look of a soldier! The secrets are the accessories: epaulettes on shoulders, cloth badges on the top of the sleeve, winding puttees on legs, and finally the pockets on the chest.

Step 4

Start adding kit. Drawing a service cap is tricky, but it gives a dark shadow on the face, and the impression totally changes – the face becomes more serious. The webbing equipment is tied around the body with buckled straps. You can change the positions of the pockets.

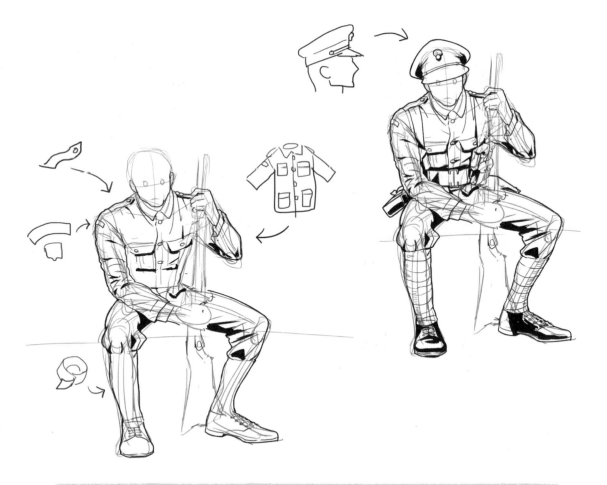

Step 5

A soldier needs a weapon. This one is a SMLE No.1 Mark III rifle. A strap is attached to carry it over the shoulder. The thin **Maru pen** lines express its wooden texture.

Step 6

As mentioned in Step 4, the cap creates an atmospheric shadow on the face. If put on diagonally, it would be enough to hide one eye, which makes a sniper-type character look canny and sharp.

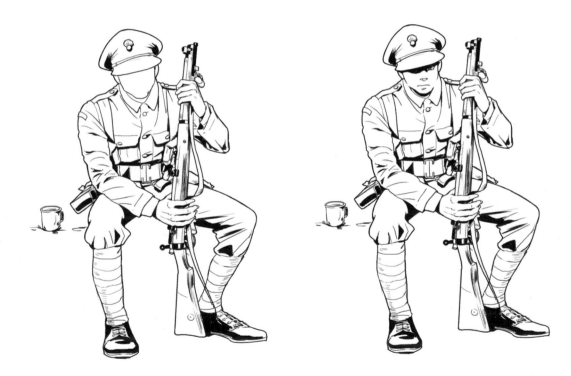

Quick Tip: Screentones save time in adding character and dimension to an image. You can buy or download a wide range of textures and finishes.

Step 7

Use screen tones to create a woodland battlefield environment. The patchy shading depicts sunlight dappling through the leaves. Now, you want to draw battledress?

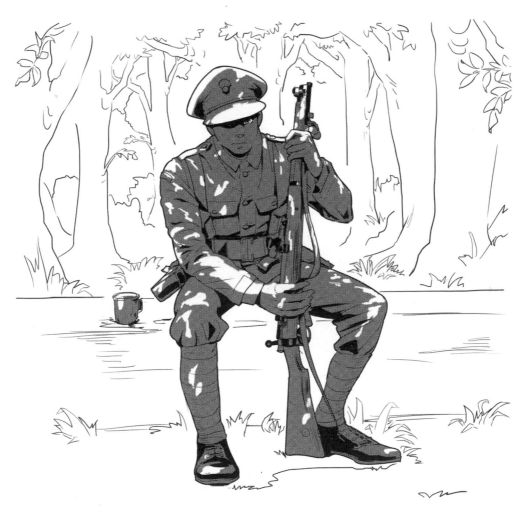

Artist Info: Images © Inko. Website: www.inko-redible.blogspot.com

MODERN MALE BY LAURA WATTON-DAVIES

Step 1

These two drawings show a rough foundation of scale for the figure. Geometric lines and shapes help to craft a structure for the drawing. Putting a slight **bend** in the line will help give a little **bounce** to your poses, so they don't look too stiff. Draw around your line sketch to **flesh out** the subject, to give them some weight.

Step 2

More detail can be added during the pencil stage. Don't be afraid to draw over faint lines, rub strokes out or just start again if you feel that your subject isn't getting the visual personality they deserve.

Step 3

Ink lines have now been added to the pencil stage. Adding more lines and creases at this stage is a good idea. The material of his clothing is slightly heavy and so will have some drape to it. Drawing crumpled, swooping curved lines on the surface and in crevices (for example, where elbows bend) works well to demonstrate this.

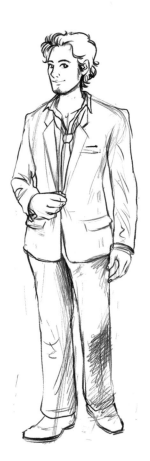

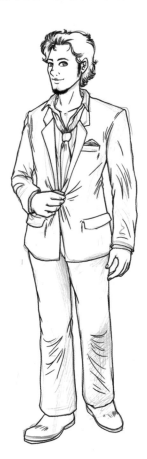

Step 4

This shows the clean inking stage. This illustration was created digitally, so the inks were placed on a **separate layer** over the pencil stage.

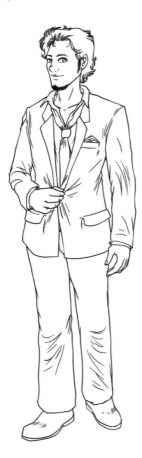

Step 5

These patterns are created using '**tones**'. Tones are plain black patterns on a transparent layer. They can be bought at specialist retailers to cut out with scalpels, then placed on inked artwork, or patterns can be found when using digital inking programs. In the artwork here, line, dot and hatched tones have been used.

Quick Tip: If inking using fineliners, pens, nibs or brushes, give a little extra time for the inks to dry – this is so that the inks will have less chance smudging when erasing out pencil lines.

Step 6

The patterns described in the previous step have been coloured digitally using one colour per type of tone pattern. The figure has been given a **stroke** and **drop shadow** effect, to help it look like a layered cut-out, floating off the page.

Step 7

Geometric shapes have been created behind the character to complement his retro vibe. Isolated figures can look a bit lonely, so surrounding them with volume (scenery, objects, graphics, other characters) helps make the composition more appealing.

The same **blending options** have been added to the shapes here, as per step 6.

Quick Tip: There will be more specialist tutorials online to help with the application of these blending options on various layers.

Step 8

Here is the final layout. The main character and the yellow graphic in the far background have been centralized for this composition. The colour scheme focuses mainly on saturated primary colours, with black and white to help highlight aspects. Feel free to experiment with complementary colour schemes!

Artist Info: Images © Laura Watton-Davies. Website: www.PinkAppleJam.com

EVENING DRESS 1
BY LAURA WATTON-DAVIES

Step 1

We started with a stick figure in a relaxed, social pose. The joints are created using small spheres and are joined together with dots.

Step 2

The next stage shows how the body volume shapes sit over the stick figure, as well as potential hair volume guidance. It is good practice to draw a number of poses and take forward the stance you are the happiest with.

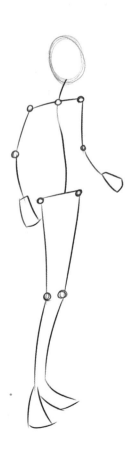

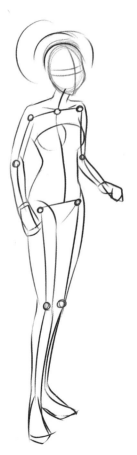

Step 3

This is the tidied pencil sketch of the figure.
There are lots of shapes here without much
detail, mainly for the skirt and the hair. At this
stage, not much close attention to the design
is needed, just structure. This can help with
speed at this stage, focusing on construction
first and foremost.

Step 4

The inking stage can utilize more details.
Long curved lines over the dress imply
hanging folds and gathering of fabrics.
Smaller, curlier strands hanging from this
characters' voluminous hairstyle (suitable
for proms or balls) add a fun and
graceful feature.

Step 5

Flower details are added separately and placed over the image to see where they will sit best. Elements of this layer have been erased to show the character's arm sitting on top of the flowers. Lines have been thickened to match line thickness of the illustration and to add some weight.

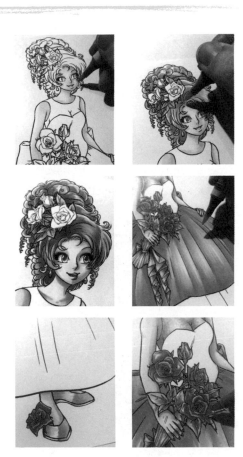

Step 6

These images show the progress from line art to final stage. Brush-tipped marker pens have been used, with the addition of **white ink rollerball pen** at the final step. Colours in each section were applied from lightest to darkest. Each stage of colour used three stages of the same colour (light to dark).

Step 7

This image details the addition of a **cool grey** for shading. The focus is on the hair and the roses because of the strong colours. This image has been scanned into a digital art program and any stray colours have been edited to be tidier around the edges.

Step 8

For a background, a pattern is created on a plain background in the digital program to create a sweet, final composition for this illustration, utilizing soft patterns and line art with colours that match the scheme of the main character's outfit. Shade is added underneath for depth.

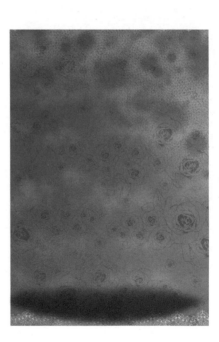

Quick Tip: Your own final illustration can be used to create prints, cards, posters and so on – good luck with your work and enjoy creating beautiful outfits for your characters!

Step 9

The final details show white lace patterns and texture added around the edges using a digital art program. The warp tools found in such programs are useful to create depth and volume by **wrapping** the flat pattern around your character's outfit.

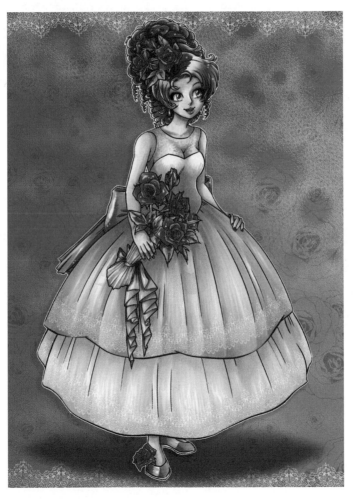

Artist Info: Images © Laura Watton-Davies. Website: www.PinkAppleJam.com

EVENING DRESS 2
BY KAT LAURANGE

Step 1

Start by sketching thumbnails and getting rough pose ideas down on paper. These can be very basic – the looser the better.

Step 2

Create a sketch based on the thumbnail of your choice. This drawing is still pretty loose, just working out the positions and proportions of the figure. Note the s-shaped line of action from head to foot, the counterpoised hips and shoulders, and the arc for positioning the elbows.

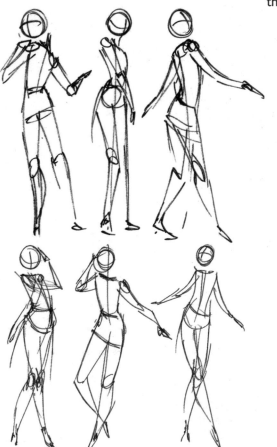

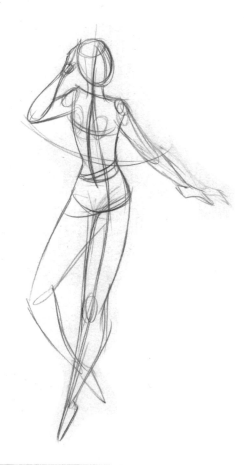

Step 3

Refine anatomy, starting to add details of form. Hands and feet are still simple shapes, and I like to leave the face until almost last, but that's just personal preference.

Step 4

Take a break for research! I searched images of evening gowns and sketched the ones that appealed to me, and researched hairstyles as well. Let your drawings here be loose and quick.

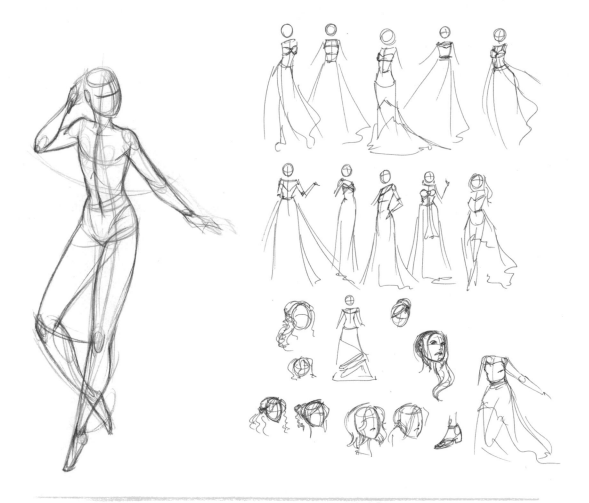

Step 5

A note on breasts: breasts are made of fatty tissue attached to the pectoral muscles. Large or small, they follow the same perspective line as the shoulders and the front of the chest. They do not grow out of the collarbones, nor do they flap about independently.

Step 6

Now that the figure is in place, sketch in the dress. I also changed her right leg position, so she is now in a standing/walking pose, instead of leaping or floating.

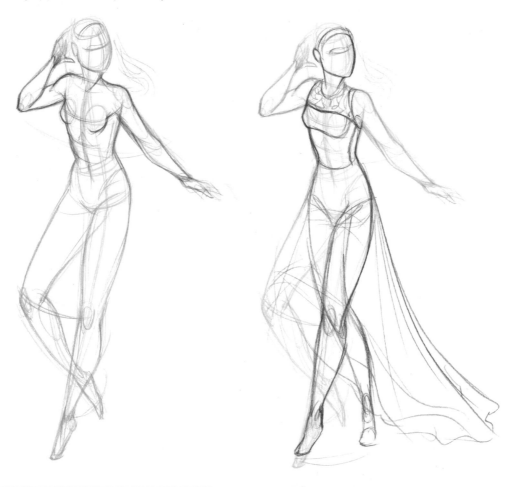

Step 7

I like to leave the face and hands for last, in case I need to change their positions before I finish the drawing, especially as they are the most complex things to draw.

Step 8

All that's left is to refine your lines and get rid of the under-drawing, and the drawing is finished!

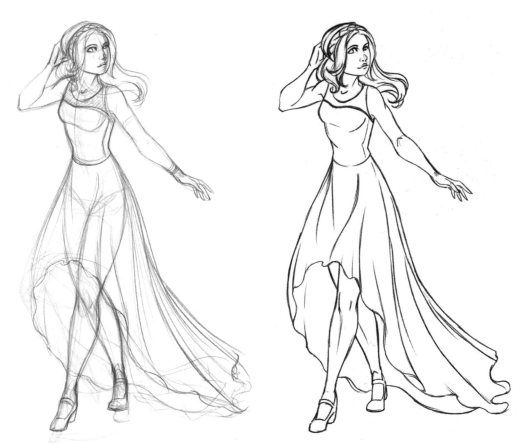

Artist Info: Images © Kat Laurange. Website: www.facebook.com/KatLaurangeArt

Making Pictures

COMBINING FIGURES

Every figure – whether human, animal or a fantasy creation – has its own proportions. Making these proportions work together shows the relationship between figures in a picture.

AN ANGRY CONFRONTATION
BY INKO

Step 1

The left-hand figure is a female, using a shoulder and elbow to protect herself – her pose shows she doesn't trust the male, who is trying to explain something with a big hand gesture. If this were a photo, the camera would be looking upwards – so the audience's point-of-view is low.

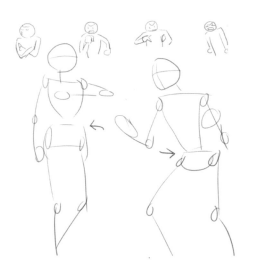

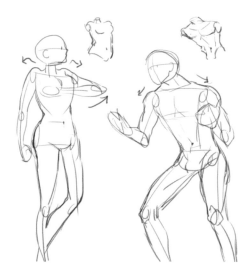

Quick Tip: An argument is made more dramatic by choosing a dramatic viewpoint – a high, low or oblique angle.

Step 2

When you strongly disagree with someone's opinion, it may make you angry. You might clutch something tightly, or brush it away. The clothing and hair trace the female's actions, and she's stepping backwards.

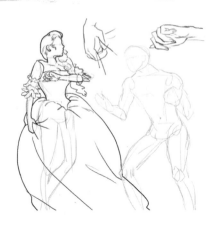

Step 3

Try out an angry expression in front of a mirror. All your energy is gathered up in the centre of the face, ready for action. The mouth is tense, whether open or closed. The flesh under the eyes tightens, eyes narrow, creating an expression of rage.

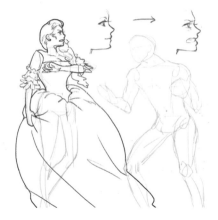

Step 4

When you are pleading or begging, you may emphasize an explanation or excuse by making a big gesture to gain attention. Does the action remind you of someone you know who is always trying to make excuses?

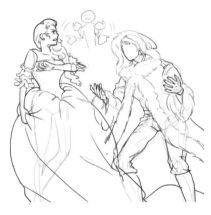

Step 5

These faces are like the female ones in Step 3, but from a different angle. See how lines became more radial in the angry face. Don't forget to draw the top teeth when you are looking up at a character, and lower teeth when looking down.

Step 6

A dramatic lighting effect! I did not demonstrate every possible shadow these characters would make – they are dense but carefully chosen. You need to understand how the fabric of the clothes are pulled by gravity and force, and how they create special shapes when you shade them. Harder materials makes sharp square shadows, softer ones make curving, organic shadows.

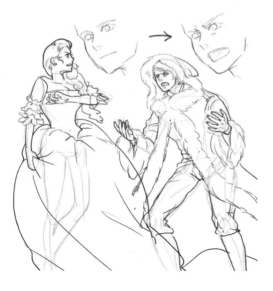

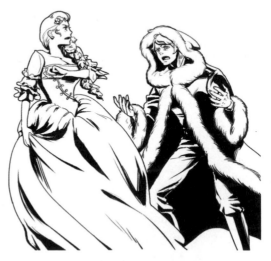

Quick Tip: To show two people in confrontation, I suggest pulling both characters' tummy inwards. The tension of the body shows dislike/disagreement.

Step 7

The background suggests the two characters are in woodlands. The tree silhouette was drawn as if trees are tenderly embracing the two. If you do not add shiny effects on tree leaves, the scene looks quite dark as you see here – that's fine, as this is not a happy moment for them.

Artist Info: Images © Inko. Website: www.inko-redible.blogspot.com

COMFORTING A CHILD
BY INKO

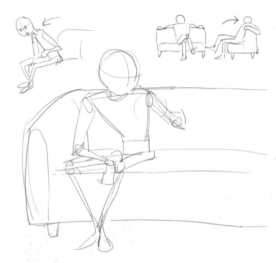

Step 1

Please put extra effort in expressing a character's feelings when you draw someone comforting another person. The two sketches at top right show a relaxed person sitting on a couch, but the figure at top left bends forward, showing the person giving extra attention to someone with whom it is sitting.

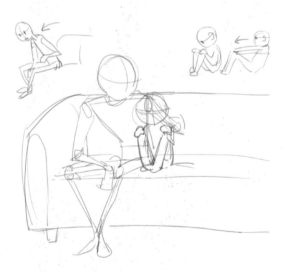

Step 2

Imagine when you're feeling blue or troubled, you don't have enough energy to sit right up and look lively. People having a difficult time – especially children – tend to curl up naturally to protect themselves.

Step 3

Start giving flesh to your stickmen.
The male body is bending forward and
his right elbow supports his upper torso's
weight. Be careful about the limbs – they
are the same length as their paired ones
no matter where they are facing.

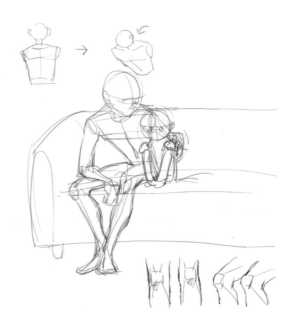

Step 4

This illustration shows the clean inking
stage. The top left sketch shows the
basics of drawing hair, which was divided
into three parts and fitted onto the head.
The bottom sketches show a boot from
various angles. Understanding a tricky
shape takes time, but helps you make a
better picture.

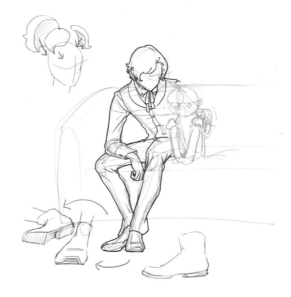

Step 5

On the right, the expression of the male
in a normal state and looking straight
ahead; on the left, at an angle and with
sympathetic expression. You can see
that eyebrows are very expressive.
He feels sad for the child, but doing
his best to smile and cheer it up.

Step 6

At the top left and bottom left are studies
of the scarf and the legs in socks. I want
to emphasize the hand study in the middle.
Draw the hand slightly curled up to touch
the child's shoulder – the man is not
clutching but tenderly patting it.
'There, there.'

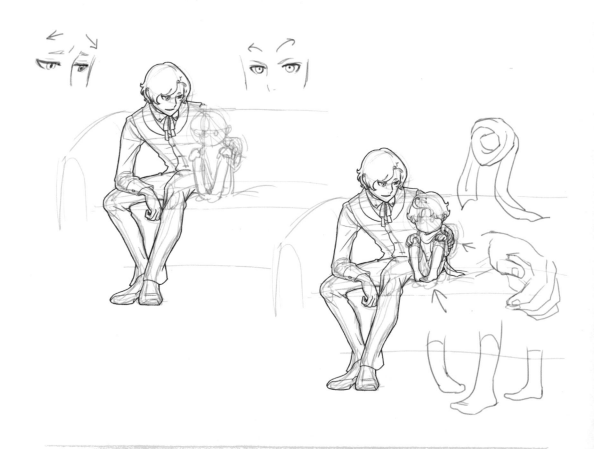

Step 7

What makes a crying expression? Look at the eyebrows, half-open eyes, teardrops, and a tightly closed mouth that goes down on both sides. Create a puddle of water on the lower eyelid, overflowing, a teardrop trickling down tracing the curve of the cheek and the crying face is done!

Step 8

Apply careful, limited shading on dark hair and clothing, inside the sleeves and under their jaws. The minimum shading and the airy background create a tender atmosphere, while dark shades and detailed background creates tension and a more threatening atmosphere. Yes, you can decide the tension of the scene with shading.

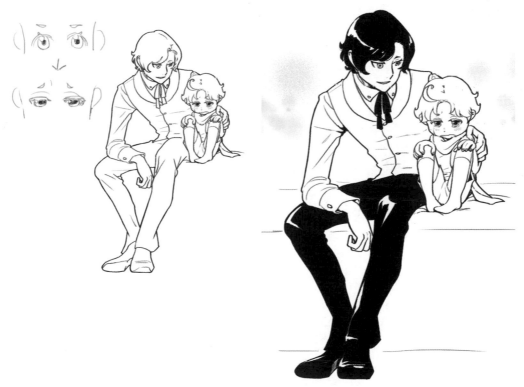

Artist Info: Images © Inko. Website: www.inko-redible.blogspot.com

WALKING HAND-IN-HAND
BY INKO

Step 1

It is very hard to draw characters walking, because there is on-going motion. Here's a step-by-step introduction. Here you see two figures of different heights walking side-by-side, holding hands and looking at each other (and also examples of their side view and feminine and masculine walks).

Step 2

What is important at this stage is how they hold hands. With lovers, or people in a critical moment, or in danger, the hold is tense, intimate or desperate. But on a relaxing walk with close friends or family, there's no need to grab hands tightly.

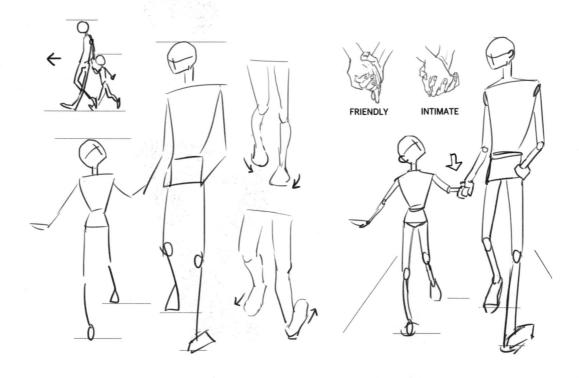

FRIENDLY INTIMATE

Step 3

Let's think about these bodies with different genders. From the juxtaposition of both figures, it is easy to spot the differences. (Can you spot the positions of their tummy buttons?)

Step 4

While walking, the male is looking at his companion's eyes. This is actually more difficult to draw than you think. Keep control of your character's eyes to make him look wherever you want his gaze to be directed.

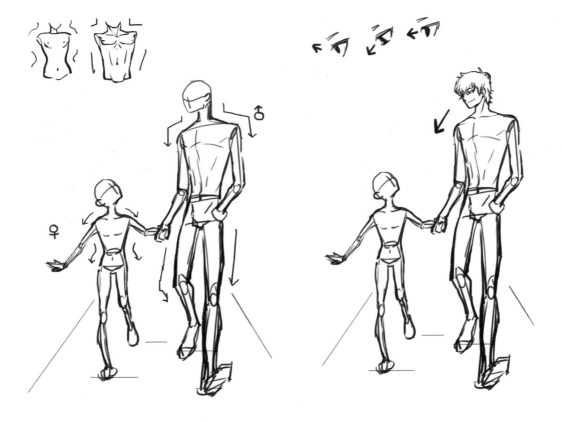

Step 5

One of the bigger tasks in this section is to make the characters look at each other. Once you try, you realize how hard it can be to draw them having eye contact. Achieve this skill and you'll always be able to create drama in your art.

Step 6

By adding something floaty or lightweight to an outfit, you have a better chance of showing the wearer's movement. As the male walks forwards, the scarf tries to remain in the same place, so it is pulled backwards by his motion. By drawing this you tell the viewer where he is moving from and to.

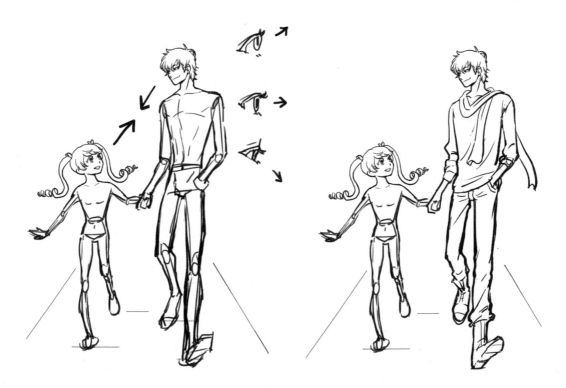

Quick Tip: You can even draw eyelines just like perspective lines, straight from the pupils of the eyes to converge on the point at which they're looking.

Step 7

Another useful point about moving clothing is that you can tell how the character walks. The girl's skirt and ribbons indicate she is skipping or hopping, which means she is feeling happy! Perhaps she is having a brilliant day with her father, big brother or favourite uncle.

Step 8

I used 'midday lighting' shade, which means the sun is high, so their shadows come right under their bodies. By knowing the various lighting effects, I can show the viewer where, when, which way and how they are walking in just one picture!

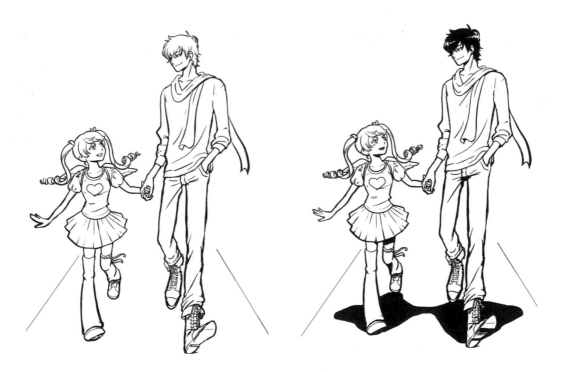

Artist Info: Images © Inko. Website: www.inko-redible.blogspot.com

PLAYING WITH A KITTEN BY CHIE KUTSUWADA

Step 1

Start with some planning sketches. Since the theme is children and a kitten, the cuteness is one of the most important things to be realized here. So, explore the possibilities in search of the cutest poses and expressions.

Step 2

Draw a more detailed rough, remembering that younger children are often rounder in shape and their heads are slightly bigger in relation to their bodies.

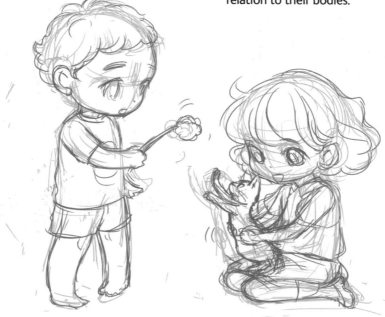

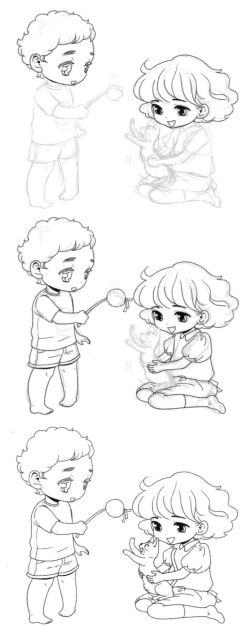

Step 3

Start inking from the children's heads. Using **rounder lines** makes the characters look soft and fluffy. If the facial features are positioned lower and slightly wider in a rounder face, the character looks younger and cuter. I often omit the nose or draw a very simple and small nose for children.

Step 4

Inking continues to the children's bodies. Again, use **soft, curvy lines**. For young children, draw the neck shorter and narrower. The younger one's legs are shorter in comparison with the older girl on the right. It is important to be conscious that the balance of their bodies change according to their age.

Step 5

Ink the kitten. Similar rules apply to most baby mammals. They – especially their faces – are rounder and the positions of their facial features are lower than in adult animals. The lines used should be soft, fluffy ones. Use reference photos for whichever animal you're drawing.

Quick Tip: Lower and wider facial features make a character look younger.

Step 6

Add finishing touches to the drawing. To show the children's excitement, I added some lines that indicate blushing on their cheeks. Also, some lines expressing the movements of the cat's toy and the kitten are added. If you can add those lines effectively, they will enhance the liveliness of your drawing.

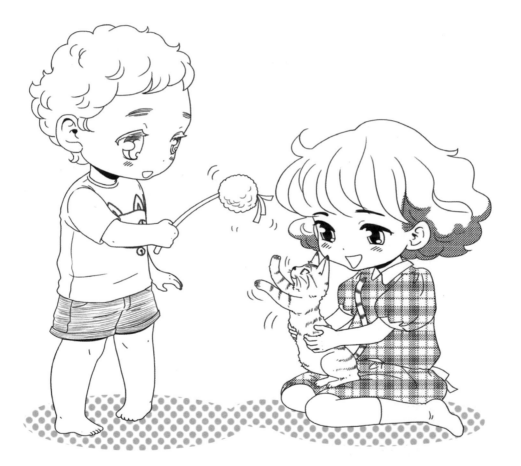

Artist Info: Images © Chie Kutsuwada. Website: www.chitan-garden.blogspot.com

FIGURES IN ACTION

Take a closer look at dynamic imagery that brings your pictures to life.

SWORDFIGHTING
BY KAT LAURANGE

Step 1

Thumbnail sketches help to warm-up the drawing hand and to get some ideas on paper. It's fun to draw and just see what happens, but pre-planning usually makes for a more successful piece of art. If you're not sure how to draw something, get references!

Step 2

An initial rough, only a little less crude than the thumbnail. For now we're just placing the figures, building up from basic shapes and drawing through where there's overlap. I drew one figure in blue and the other in red to help differentiate them.

Step 3

Refine the anatomy. We're still not worrying about fine details, concentrating instead on broad strokes and general placement. I roughed in guidelines for the blue guy's face, adding muscle mass on the previous figures in Step 2.

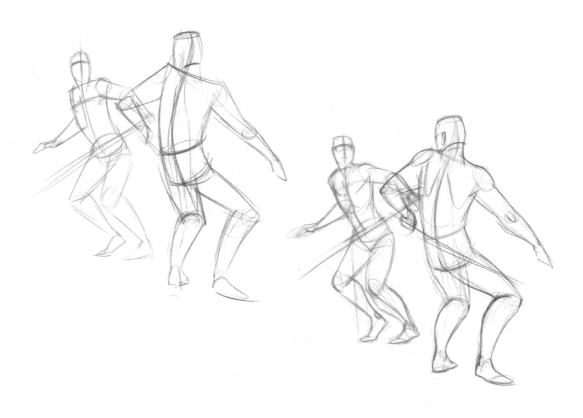

Step 4

Research time! I'm a history buff, so I decided to draw a Royal Navy captain battling a pirate. I researched naval uniforms, swords and pirate garb, as well as nineteenth-century hairstyles.

Step 5

Add details. I've given the blue figure his post captain's uniform, and the red figure a loose jacket and trousers. It's helpful to add clothing after the anatomy is in place, so that the fabric can wrap realistically around the figure. Flowing lines add a sense of motion.

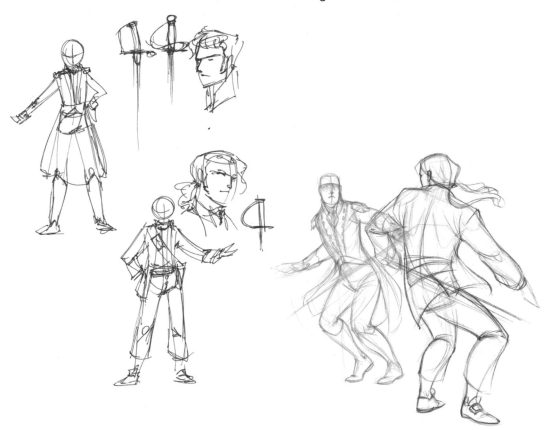

Quick Tip: Flip it! Mirroring your drawing can reveal flaws (asymmetry, funny anatomy) you may not otherwise notice, and help you to fix them.

Step 6

Final details. I've finished the captain's face
and both characters' hands. Note I did some
hand studies in the margins of the drawing,
to make sure I had them right. I also
changed the captain's expression, to make
him a little more fun.

Step 7

Final lines. This is the step where you bring
the drawing together, making your pencils
as tight or as loose as you see fit. From here
you can add colour, a background or
whatever you like.

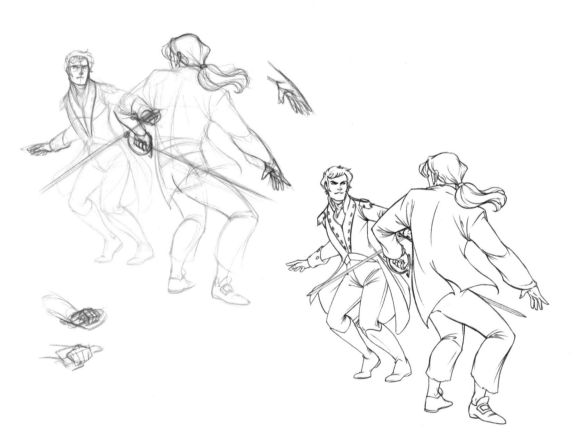

Artist Info: Images © Kat Laurange. Website: www.facebook.com/KatLaurangeArt

SHOPPING
BY BRUCE LEWIS

Step 1

Shopping is not just about 'buying stuff' – it's also a social activity. So I've constructed a two-person pose here using the mannequin method; I sketched the pose from a photo.

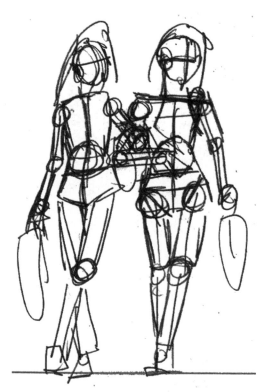

Step 2

I've fleshed out the figure on the left. Now I'm lightboxing the sketch over a sheet of paper with head-lengths roughly measured out, to make sure the drawing is realistically proportioned. The figure is eight-heads tall because she is a fashion model: tall, lanky and skinny.

Quick Tip: The best results come from drawing from life; however, if you can't sketch real people, look at photo references as you draw. Never trace!)

Step 3

I've sketched in the other figure, again from a photo ref. You should use '**landmarks**' to keep everything in the right place as you draw. E.g., the right eye of the model on the right is directly over the centreline of her body. By using landmarks like this, you'll keep your figures proportional and balanced in relation to one another.

Step 4

Now the fun part: detailing and finish! Close-up viewing of the photo allows me to draw in important details. My style of drawing is line-based, so even though this is a realistic drawing I stylized certain portions of the image in order to fit the overall look.

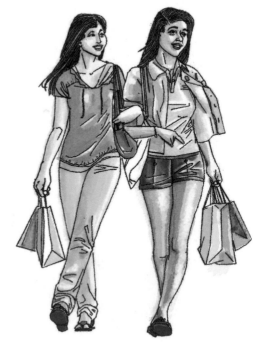

Step 5

A complete discussion of perspective lies outside the scope of this book. It is, however, imperative that you grasp the basic concept of drawing in perspective (*see* Chapter 4). Look at this scene: see how the lines forming the edges of the windowsills, pavement, etc., all converge?

Step 6

You need not colour your final drawings. A lot of fun can be had by using **blocks** of solid black, patches of solid white, and **gradated tones** in between. The idea is to 'spot' your solid black and blank white forms to create a lively and stimulating pattern.

0 1 m

Step 7

Shopping scenes often involve images in close-up, where the horizon may not be visible. As a result, the vanishing point may not even be within the frame of the image you're drawing. Imagine the VP hovering off in space somewhere nearby, and sketch the convergent lines centring upon it in freehand.

Step 8

Internet shopping is more like simply 'buying' than shopping. More and more people choose to buy online these days so it's a good idea to know how to draw people pointing and clicking. I drew this guy freehand, without reference, just for fun. Try a freehand drawing yourself and see how it goes.

Artist Info: Images © Bruce Lewis. Website: www.brucelewis.com

FIGHTER PLANE IN FLIGHT
BY INKO

Step 1

In this project we'll try drawing a fighter plane in flight step-by-step. First of all, understand the shape of it, studying sketches A, B and C. Moving objects should be at an angle in order to create a dramatic look.

Step 2

Now you know why the plane should be at an angle. Yes, because it looks three-dimensional! Normally you do not see anything as a straight-on moving figure. When you design a new plane, remember that it is an aerodynamic shape in order to be less air resistant.

Step 3

Let's think what to add to make it look like a fighter plane. Not only a cockpit, wings, and hatch, a fighter plane also carries weapons to be able to attack in/from the sky. Of course you can design what to carry!

Step 4

Start inking. You can make mistakes or change designs in Steps 1 to 3 in pencil, but from here you need to pick the most important lines only. Use a **thick G pen** and draw the outlines of the plane.

Step 5

Swap to a **thinner Maru pen** to start drawing details. Imagine how parts are created separately and assembled together, so that you start seeing the necessary lines to add.

Step 6

Add shading underneath wings; shiny effects will make the plane body look slick and solid. Give extra shine on glass parts. You can also add smudges of dirt and eroded paint.

Step 7

Finally add speed lines, which you can trace to the vanishing point. Move your arm and hand faster to create straight edgy lines. Smoke and air pressure effects can be added, too. Does the plane now look as if it's flying?

Quick Tip: Pay special attention to straight lines to convince the viewer that this is a solid metal object.

Step 8

Even faster! Add more speed lines on the background for faster moving expression. Here all lines are drawn towards the vanishing point we had in the previous step, from exactly where this plane was flown! And it is done!

Artist Info: Images © Inko. Website: www.inko-redible.blogspot.com

TENNIS BY BRUCE LEWIS

Step 1

Tennis is a game of stretching. This means that when you draw a tennis player in action you should be prepared to depict the human body in poses that appear, well, unnatural. Take the player in this stock photo. His arms and legs are stretched to their full lengths as he closes in on the ball.

Step 2

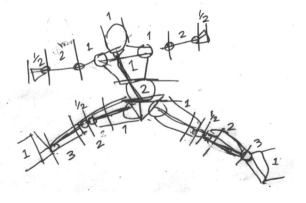

To get the drawing going, I lightboxed the photo, then drew this stick figure in order to establish proportions. The measurements are in head-lengths. This will be the basis of my figure.

Step 3

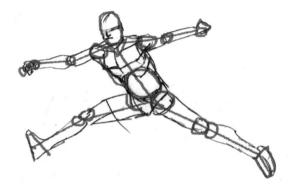

Using the stick figure, I frame out the arms and legs using the time-honoured ball-and-cylinder cylinder method. So far, so good.

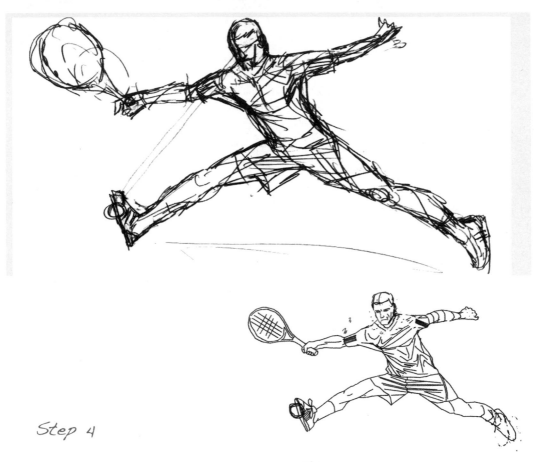

Step 4

Now I lightbox the frame sketch and begin draping the figure. Notice the folds: the shirt is clinging to the player's sweat-soaked torso and the shorts are tight on one leg; loose on the other. Both garments are in tension, they are being pulled taut by the position of the player's body.

Step 5

Here's my first attempt at a rough draft. The positioning of the head and arms is a bit off, and I don't like the guy's facial expression, but overall the basic form looks pretty solid.

Quick Tip: Is the clothing being pulled taut on the figure? This will affect the folds in the fabric when you draw them.

Step 6

As I adjust the body positioning in successive sketches, I'm also trying to preserve the tension and flow of the pose. The position and extension of the torso and limbs often creates flowing, curved lines. I want to preserve that flow in my drawing.

Step 7

My final pose here is different in some respects from the photo. The optics involved in photography create distortions; straight lines become curved, curved lines straight, and so forth. Photographic images also flatten all perspective (3D) into a 2D plane, making long objects (e.g., limbs) look weird and stubby due to the lack of perspective foreshortening.

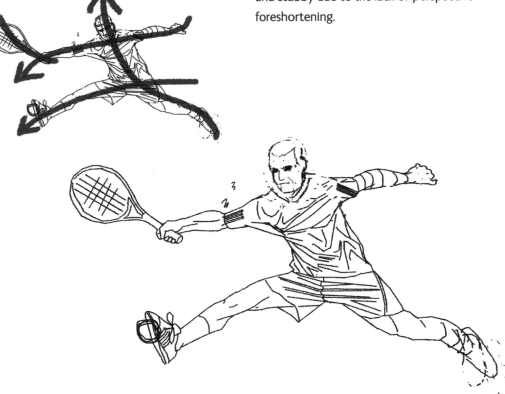

Quick Tip: Use photos as reference material, but don't trace! Look at the photo image, and then imagine the flat, 2D objects and people therein as solid 3D objects.

Step 8

Here's the finished sketch. I stylized the image, without sacrificing important details. I also redrew the arms and legs in such a way as to suggest the twisting moves of the player. This should be your goal: to depict the tennis player in a realistic manner that is also consistent with your own creative style.

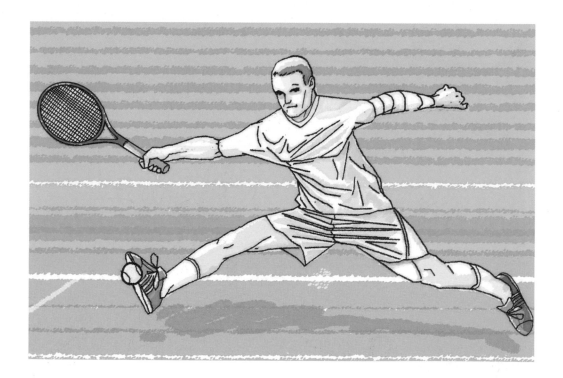

Artist Info: Images © Bruce Lewis. Website. www.brucelewis.com

DANCING BY BRUCE LEWIS

Step 1

Dance is movement-as-art. Notice how
the position of the arms and legs of
these two fine dancers suggest curves,
waves, and upward, flowing movement?
That is what you want to capture when
drawing dancers.

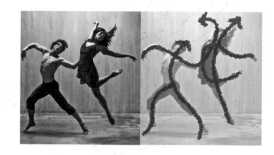

Step 2

Let's start with a good old stick figure. See how I used curvy, sweeping, noodle-like lines instead of
stiff sticks? That's the pose I'm talking about. Attending an actual dance performance or watching a
video of dancers can help. The idea is to create curved, flowing lines.

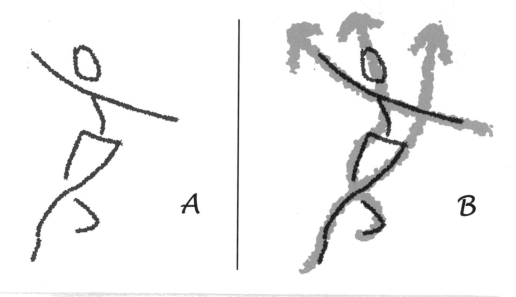

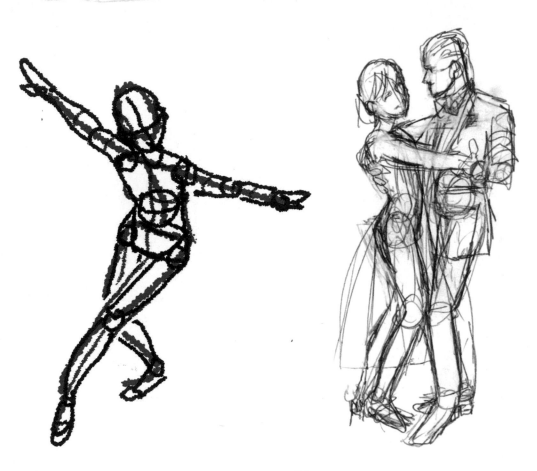

Step 3

Once you've got the pose you want, use the ball-and-cylinder technique to bulk out the basic body shape around the stick figure. With a live model or photo reference for detail, you could probably generate a good drawing from this sketch alone.

Step 4

Let's draw a cosy couple at a social dance. The gent holds the lady in the crook of his right arm whilst simultaneously holding her right hand in his left in a taut and elevated position. Her left arm is over his right arm, her bent right leg is inboard of his bent left leg, and their bodies are pressed together hip to hip.

Step 5

Now, the basis of couple's dancing is the turn. At the centre of everything that turns is a line about which that thing spins – the axis of rotation. If you think of the line where the couple's bodies are touching as being the axis of the dance (A), it becomes easy to 'feel' how the turning will affect their figures: it will tend to sort of sling them outwards as they turn (B). This axial motion creates the dynamic lines (B) that make this pose so much fun to draw.

Step 6

Now let's flesh out this sketch. I've used the ball-and-cylinder method to create a nice, flowing pose; the details of the bodies of the dancers and their accoutrement I borrowed from a stock photo. Notice how the flowing, rhythmic movement of the sketch is reflected in this finished piece?

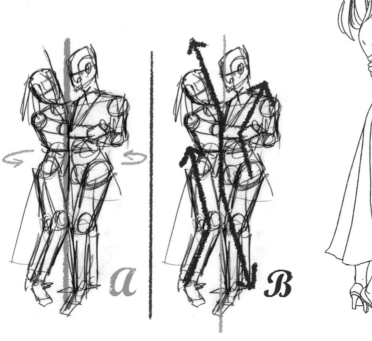

Step 7

There are many varieties of dance. By using this stick-figure/flow method, you can depict any of these. Ultimately, the best way to truly get the feel of dancing is to go dancing yourself – or at least watch real people dancing. Bring a camera and a sketchbook. You'll be glad you did.

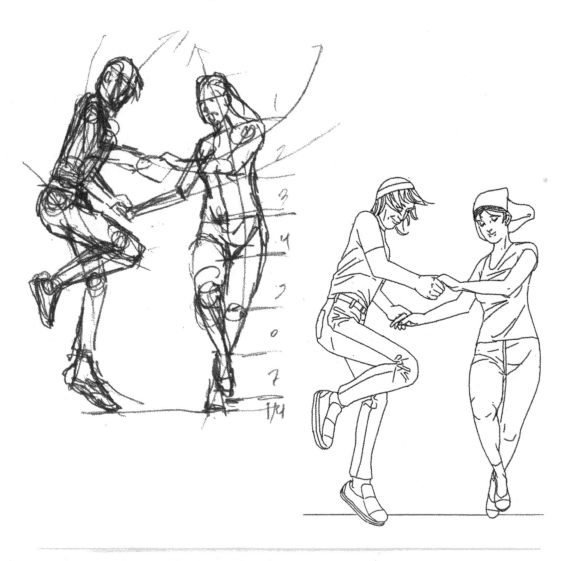

Step 8

The key to keeping that dance mood lies in understanding what dancers actually do out on the floor. They're not walking firmly on their feet. They're not even balanced. In fact, both members of a dance couple are deliberately off-balance.

Look at the close-up here. The red arrows represent the legs the dancers' 'weight' is on – that is, the leg that is holding each dancer up. In this case, their entire weight is on the outboard leg (his right, her left). Since both are off-balance, both are falling, in this case towards the inboard leg (her right, his left). If not checked, they'll end up in a heap on the floor.

But they don't fall, because they are checking the fall. They do this by swinging their weight onto their bent legs while turning around the axis (green arrows). This has the effect of switching the 'weight' of the couple back and forth.

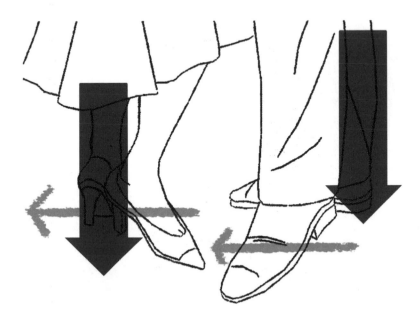

Artist Info: Images © Bruce Lewis. Website: www.brucelewis.com

MEET THE TEAM

Get to know the artists and writers who made this book, and find out where you can see more of their work. They're a very diverse group, from a wide range of backgrounds. Some make their work entirely on the computer, while others use some traditional techniques, but most mix their media to achieve the best effect. Their passion for drawing is the common thread that unites them all.

HELEN McCARTHY – GENERAL EDITOR

Helen McCarthy has edited two magazines and written over a dozen books published in six languages – English, French, Italian, Korean, Chinese and Japanese – as well as contributing chapters and essays to many academic publications, and writing for magazines and online. This is her second book on drawing for Flame Tree.

Helen is a needlework designer and costumer with experience in both museum reproductions and theatre costuming. She's been making textile art since childhood and has written a book and given workshops on *Manga Cross-Stitch* – a combination of embroidery and Japanese pop culture.

She makes poems in both print and embroidery, and produces art from a mixture of needlework, inkjet printing, collage and found objects.

Helen speaks at universities, colleges, libraries and art institutes in the Europe, the US and Japan. She also curates film seasons and leads workshops on comic making, costume, needle art and writing.

Her work has won several awards, including a Japan Festival Award for promoting Japanese culture and a Harvey Award for her book *The Art of Osamu Tezuka: God of Manga*. She lives with her illustrator partner in London, England.

Websites
helenmccarthy.wordpress.com
@tweetheart4711

Animal, mineral, vegetable ... anything can be a character in the world that Dan has created. However, the story has a serious tone in part, so to keep the reader grounded in reality he uses photography of his own London suburb for the backgrounds, giving the story a true urban street edge. *Bad Egg* is entirely created by Dan: the script, the art, the layouts, the photography and the editing.

Websites

www.facebook.com/badeggcomic
www.twitter.com/badeggcomic

DAN BYRON

For as long as he can remember, Dan Byron has spent most of his free time drawing. Cartoons and comics have always enthralled him. He feels there's something truly incredible about an artist dedicating a bulk of their lives to sharing their own unique vision and style with the world.

In his work, Dan wanted to incorporate the elements he admired from all global art styles into something that could really be called a British comic: *Bad Egg*. He decided to have no human characters in order to open up the possibilities of what the medium can do.

EMMELINE PUI LING DOBSON

Emmeline has been drawing ever since she was little, first imitating the pictures in *Fighting Fantasy* gamebooks, then creating her own monsters, robots and brave adventurers to explore mysterious worlds. The 1990s introduced her to Japanese visual culture through video games and anime, and in that era she started making and self-publishing comics.

By 2009, Emmeline had worked in the UK video games industry for a decade. In the same year, she started to diversify her

working life; since then she has lectured on games courses, done work for colleges and universities, and completed numerous freelance contracts. This allowed her to refocus on making comics. Being an independent creator had become sidelined to her employment as a games designer, despite offering more personal artistic freedom. She studied writing, too, and today Emmeline is a freelance illustrator and hybrid artist/writer for her most significant self-directed project, *Knights of Eve*.

Emmeline loves making manga-style images because they are full of an indescribable energy that excited her as a teenager. She also reads and learns from an international range of comics traditions, and has a deep respect for the skills of the expert draftsperson. As long as she can create great artwork and tell stories that have depth, convey heartfelt meaning and entertain, she

is not discouraged. She feels this is a wonderful era when learning resources for any software or technique are at our fingertips. She has stories she passionately wants to communicate from her heart to the hearts of her audience.

Website
www.emeraldsong.com

NEWTON EWELL

Newton Ewell was born in 1962 in St. Louis, Missouri, USA. He's always wanted to be a starship engineer. From childhood, he has been obsessed with science fiction hardware. His love affair with mecha began when he was just three years old, thanks to a man named Gerry Anderson. Meanwhile, Newton was also

getting into Japanese SF anime with shows like *Prince Planet* and *Astro Boy*, as well as becoming a fan of Japanese live-action special effects shows such as *The Space Giants*.

Newton taught himself how to draw and paint so that he could make the pictures he loved. The result has been a career as an illustrator, conceptual and production designer, and mechanical design contributor to a number of role-playing game publications. This experience helped Newton get work on videogames. He's at home with both traditional and digital artwork, from pencils to 3D animation. He's looking forward to working with games companies on many future projects in the fantasy, SF and horror genres.

Newton also accepts private commissions and has recently returned to illustrating RPGs. Now, more than ever, he feels it's a time to create, to be seen and heard, to follow and build on your passions. He feels fortunate to live in a time where whole worlds can be created in the home computer and on the drawing board. Mastering this magic has made his dreams of adventures with mecha in space come true.

Website
www.newtonewell.com

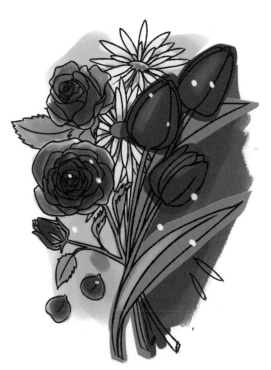

LEA HERNANDEZ

Lea has been a comicker for more than 25 years and has published in print and on the web. She was one of the first comics creators to bring a print series to the web (*Rumble Girls: SWT* in 2002). She has drawn comics and/or covers for Marvel, DC, Dark Horse, Boing Boing, Oni, IDW and Disney, on titles such as *Teen Titans Go!*, *My Little Pony*, *Adventure Time*, and *The Little*

Mermaid, as well as four original graphic novels, one licensed one, and a manga how-to book.

Lea says, 'I want you to know that the key to improving as an artist is *lots* of practice, to be kind to yourself as you learn, and that you are *never* too young or old to learn! I took a painting class from Disney artist Chris Oatley last year, and made tremendous strides in my work!'

Some of her favourite books, comics, TV shows and movies are: 'Steven Universe', *Seraphina* by Rachel Hartman, 'The Unbreakable Kimmy Schmidt', *The Secret of Kells*, *Big Hero 6*, *Ratatouille*, *The Incredibles*, *The Last Unicorn*, 'Sailor Moon', *Revolutionary Girl Utena*, *Laputa*, *The Fifth Element* and *The Snow Queen* by Joan D. Vinge.

She lives in Los Angeles, California with writer/editor husband David, a dog and a cat. Her grown-up children are creative types as well, and she's currently writing and drawing her sixth graphic novel, *The Garlicks*.

Websites
www.divalea.deviantart.com
@theDivaLea

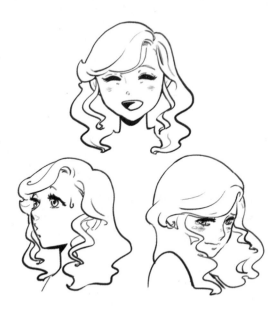

INKO

Inko is a Brighton-based Japanese freelance artist, producing cartoons, illustrations and picture books. She grew up in Kyoto, a very traditional and arty area of Japan. Ever since she could read, Inko has loved comics. She graduated from Kyoto Zokei University of Art and Design in Japan, and went on to study at Central Saint Martin's College of Art and Design in London, England. Inko's artwork is heavily influenced by both Japanese traditional art and Japanese pop art. To this traditional foundation she adds her original style, which often has a feeling of darkness and a mystique all of its own.

She teaches how to draw, and has given talks for both children and adults at schools, museums, galleries and libraries all over the UK, including the British Museum and the Victoria and Albert Museum. Inko is also active in many art projects including short film animations and comic strip posters for 'Art On The Underground'.

Inko is collaborating with Chie Kutsuwada on an on-going web comic project, an anthropomorphism of London Tube stations: *Go! Go! Metro!* Her collaborations with other contemporary artists include work with David Blandy, and the Inktober online project.

Inko's manga can be found in *MangaQuake*, *War*, *Howl!*, *Tempo-Lush Tales* and more comic anthologies. She has illustrated many stories including *Ketsueki* by Richmond Clements, *Rachel Moves To Brighton* by Morag Ramsay, and *Rosie and Jacinda* by Richy K. Chandler.

Her first illustration book *Uniform Girls* will be published in May 2015, and she has plans for many more publications and projects in the future.

Websites

www.Inko-redible.blogspot.com
www.art.tfl.gov.uk/project/1141
www.gogometro.blogspot.com

CHIE KUTSUWADA

Chie Kutsuwada was born and brought up in Japan. She moved to England to further her studies, graduating from the printmaking department of the Royal College of Art, London. She is now based in Brighton, working as a professional artist.

She writes and illustrates her own comics, as in her first published *King of a Miniature Garden* (included in *The Mammoth Book of Best New Manga 2* from Constable & Robinson in 2007) and *Moonlight* (collected in *The Mammoth Book of Best New Manga 3* from Constable & Robinson in 2008.)

Chie also works with other writers, including William Shakespeare in *Manga Shakespeare: As You Like It* (SelfMadeHero, London, 2008) and *The Book of Five Rings* by Musashi Miyamoto (adapted by Sean Michael Wilson and published in 2012 by Shambhala in Boston and London). She is currently collaborating with Inko on an on-going web comic project, an anthropomorphism of London Tube stations: *Go! Go! Metro!*

Chie also attends many art-related events in and beyond the UK. She runs workshops at schools, libraries and museums including the British Library and the Victoria and Albert Museum. Chie's work is deeply influenced by manga but she enjoys drawing many other genres, from samurai fighting to horror.

Website
www.chitan-garden.blogspot.com

KAT LAURANGE

Kat Laurange has been drawing since she could hold a crayon. She trained in traditional (hand-drawn) animation at the Art Institute of Dallas, and has since meandered about the realm of freelancing, working for a time in the local animation industry as a character designer, storyboard artist and animator for commercials and direct-to-DVD television shows.

More lately, she has been drawing superheroes on little cardboard rectangles, and her work has been included in trading card sets licensed by Marvel, DC Comics and others. When she is not hunched over her drawing desk, she can be found mucking about in her garden, napping in a sunbeam with her many cats or, more likely, running after her inexhaustible little boy – and always, always, with a coffee cup in hand.

Website
www.facebook.com/KatLaurangeArt

teaching extremely popular drawing workshops. The book has also been translated into Chinese to help the millions of manga fans in China to create their own comic art.

When not drawing or writing, Bruce works as a professional vocal performer in the broadcasting, voice-over and anime dubbing industries. Bruce lives in Tarrant County, Texas, USA.

Website
www.brucelewis.com

BRUCE LEWIS

Bruce Lewis is an illustrator, writer, graphic designer and vocal performer. One of the first American comic artists to work professionally in the manga idiom, Lewis has produced hundreds of pages of comics since 1993. In addition, he has spent many years working professionally in the advertising and entertainment industries as an art director, advertising artist and designer.

He is the author of *Draw Manga: How To Draw Manga In Your Own Unique Style* (Collins & Brown, 2005), a best-selling how-to book based upon his two decades of

TONY LUKE

Tony Luke has been a professional artist for over 25 years. His big break came in 1993 when Kodansha published his 'Dominator' serial in their anthology monthly *Comic Afternoon* alongside 'Gunsmith Cats' and 'Oh! My Goddess'. 'Dominator' first appeared in black and white in music magazine *Metal Hammer* in 1988 before exploding into Japan in full colour.

Tony was the first Briton to have a self-created comic series published in a Japanese anthology. He followed this up with animation work on the TV pilot 'Archangel

Thunderbird', and in 2003 an animated adaptation of 'Dominator'.

Tony has worked with some of the biggest names in comics and animation in Britain and Japan. He now freelances on a variety of projects and commissions.

His advice to beginner artists is, 'Don't be held back by invisible "rules" – just experiment and try different things out until you find your own, unique, voice.'

Website

www.tonyluke.deviantart.com

KRISTEN MCGUIRE

Kristen McGuire is an American comic book artist, writer and voice actress. She has been drawing her own comic books professionally since 2008. Kristen can be seen at anime and comic conventions all across North America where she sells her comics and speaks on panels ranging anywhere from basic drawing to voice acting. Her comic titles are *Enchanted* and *A Day in the Life of a Cat Girl* and can be purchased from her website at www.kriscomics.com.

Kristen is also a voice actress and has worked with companies like FUNimation to provide the English voices for characters like Hinano Kurahashi in *Assassination Classroom* and Vera in *Maria the Virgin Witch*.

Websites

www.kriscomics.com
facebook.com/kriscomics

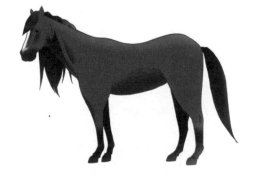

LAURA WATTON-DAVIES

PinkAppleJam is the online name Laura uses for her various illustration and personal work projects, a selection of which are featured in this book. She hopes readers will enjoy them and be inspired to draw their own characters too.

Her work has been published via Letraset, Sheffield's 'Skool Disco' nightclub event, *Shout* Magazine, the UK Japanese Embassy, Tokyopop, *NEO* Magazine, plus others. Working remotely from her studio in Cambridge, England, she has worked on comics, games, flyers and numerous other art projects for years. She has also hosted how-to workshops in libraries and schools around the UK.

Laura was part of British anime and manga fandom in the early 1990s and is one of the founders of British manga collective Sweatdrop Studios. A steady interest in comics and animation worldwide from a young age developed into other interests, such as games, pop fashion and art in general. Combined with the internet, she believes that there are unlimited possibilities for new ideas.

The culture of making comic arts is very important to Laura. Over 20 years she has created her own works, including stories featured in Sweatdrop Studios' anthologies and solo comics. *Biomecha*, her on-going manga style comic, was shortlisted for the 2007 Eagle Awards.

Websites
www.PinkAppleJam.com
www.BiomechaComic.com

FURTHER READING & USEFUL WEBSITES

The best way to learn to draw is to draw as much as possible – but if you've enjoyed learning from this book, you might like to try some more books that have helped artists improve.

You can also search the web for tutorials. There are millions where you can see artists create their work in real time. It's worth spending time checking out which artists you admire and find easy to follow.

FIGURE DRAWING

Bergin, Mark, *How To Draw Portraits, Faces and Heads*, Book House, 2010

Bergin, Mark, *The Human Figure (How To Draw)*, Book House, 2009

Hodge, Susie, *How To Draw People: In Simple Steps*, Search Press, 2013

Hogarth, Burne, *Drawing The Human Head*, Watson-Guptill, 1989

Hogarth, Burne, *Dynamic Figure Drawing*, Watson-Guptill, 1984

design.tutsplus.com/articles/how-to-draw-different-body-types-for-males-and-females—vector-7542
Tutorial on how to draw different body types.

design.tutsplus.com/articles/paint-realistic-hair-using-photoshop—psd-14540
How to create realistic hair on Photoshop.

www.drawninblack.com/2009/10/how-to-draw-hands-35-tutorials-how-tos-step-by-steps-videos-studies-poses-and-photo-references
35 different tutorials on how to draw hands.

www.easydrawingtutorials.com
A website for easy tutorials on how to draw your favourite characters.

www.ratemydrawings.com/tutorials/portrait/178-Drawing_different_kinds_of_Eyes.html
Tutorial on drawing different types of eyes.

GENERAL DRAWING

Barber, Barrington, *The Complete Book of Drawing*, Arcturus Publishing, 2009

De Reyna, Rudy, *How To Draw What You See*, Watson-Guptill, 1996

Kistler, Mark, *You Can Draw In 30 Days*, Da Capo Lifelong Books, 2011

Linley, Mark, *How To Draw Anything*, Right Way, 2009

Watson-Garcia, Claire, *Drawing for the Absolute and Utter Beginner*, Watson-Guptill, 2000

www.ctrlpaint.com
A website full of short video tutorials covering all sorts of aspects of digital art.

design.tutsplus.com/tutorials/introduction-to-digital-art—psd-13528
An introductory video tutorial on digital art.

drawsketch.about.com/od/learntodraw
A website full of articles on beginner drawing ranging from how to hold a pencil to how to shade an egg.

www.dueysdrawings.com/drawing_materials. html
This website has instructions on what materials to use for beginner drawing.

howtodraw.pencilportraitsbyloupemberton.c o.uk/step-by-step-drawing-tutorial/pencil-drawing-techniques
Step-by-step tutorial on pencil drawing techniques.

www.instructables.com/id/Digital-Painting-Lesson-1-The-basics-of-using-a-gr
Basic tutorial on how to use a graphics tablet for digital art.

www.instructables.com/id/How-to-Draw---Basic-Linear-Perspective
Basic tutorial on how to draw basic linear perspectives.

www.melissaevans.com/tutorials/pencil-sketch-to-smooth-digital-shading
Tutorial on smooth digital shading using Photoshop.

www.onlypencil.com/blog
Some easy tutorials on how to draw with pencil, with new techniques every day!

www.youtube.com/watch?v=aU2bIy08D_g
A tutorial video on beginner digital art.

www.youtube.com/watch?v=felys-u4nfk
A very useful tutorial video on one- and two-point perspective.

www.youtube.com/watch?v=8V5c7Ld0N5A
A quick YouTube video on beginner sketching techniques.

DRAWING STILL LIFE, NATURE AND LANDSCAPE

Berry, Kate, *Drawing and Sketching Nature*, Kate Berry, 2013

Poxon, David, *The Still Life Sketching Bible*, Chartwell Books, 2008

Willenbrink, Mark and Mary, *Drawing Nature For The Absolute Beginner*, North Light Books, 2013

DRAWING COMICS

Lewis, Bruce, *Draw Manga: Creating Manga In Your Own Unique Style*, Collins & Brown, 2005

McCloud, Scott, *Making Comics: Storytelling Secrets of Comics*, Manga and Graphic Novels, William Morrow, 2006

McCloud, Scott, *Understanding Comics: The Invisible Art*, William Morrow, 1993

INDEX

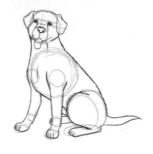

Artists' websites

Dan Byron: www.facebook.com/badeggcomic
Emmeline Pui Ling Dobson: www.emeraldsong.com
Newton Ewell: www.newtonewell.com
Lea Hernandez: www.divalea.deviantart.com
Inko: www.inko-redible.blogspot.com
Chie Kutsuwada: www.chitan-garden.blogspot.com
Kat Laurange: www.facebook.com/KatLaurangeArt
Bruce Lewis: www.brucelewis.com
Tony Luke: www.tonyluke.deviantart.com
Kristen McGuire: www.kriscomics.com
Laura Watton-Davies: www.PinkAppleJam.com

 FLAME TREE PUBLISHING

Creators of fine, illustrated books,
ebooks & art calendars

www.flametreepublishing.com
blog.flametreepublishing.com